Precious Vessels

三十輻共一轂當其無
有車之用埏埴以為器
當其無有器之用鑿戶
牖以為室當其無有室
之用　右錄道德經　王壹生書

Eldon Worrall

Precious Vessels

editor Margaret Warhurst

2000 years of Chinese Pottery

Merseyside County Museums

© Copyright Eldon Worrall 1980

ISBN 0 906367 07 7

Set in Monophoto Times New Roman by August Filmsetting, Stockport

Printed by Rockliff Brothers Ltd, Long Lane, Liverpool

Calligraphy by Brian Wang

Designed by Barrie Jones

Reign Marks on page 13 reproduced from
A Handbook of Chinese Art by Margaret Medley
with kind permission of Bell & Hyman

Contents

致虛極守靜篤萬物並作吾
以觀復夫物芸芸各復歸其
根歸根曰靜是謂復命復
命曰常知常曰明

錄道德經 王昌生書

Foreword

The enormous task of rebuilding the Museum after its near destruction in the Liverpool blitz of May 1941 has until recently allowed little time for resuming scholarly assessment of the collections. As a result some important aspects of the Museums' collections, including the Chinese ceramics, have remained virtually unknown to scholars, collectors and the visiting public.

Gradually, however, progress is being made in this important area and I am indebted to Eldon Worrall, who for many years has studied the Chinese ceramics in the County Museums and whose work has made possible the publication of this catalogue. My thanks also go to Margaret Medley, Curator of the Percival David Foundation of Chinese Art in the University of London for her help and advice over a long period, and to Margaret Warhurst, Keeper of Antiquities in the County Museums who both arranged the exhibition and edited the text of the catalogue.

Richard Foster
Director of Museums

大成若缺　其用不弊

大盈若冲　其用不窮

大直若屈　大巧若拙

大辯若訥

錄道德經

王臺生

Tao Te Ching, book two, verse 101

Introduction

As befits a great maritime city such as Liverpool, the museum is well provided with art objects from the orient, and the Chinese ceramic collection provides the visitor with a reasonable cross-section of material in this medium. Although it is not a large collection there is an emphasis on the later 17th and 18th century material. This is not surprising when it is remembered that the British East India Company received its charter in 1610, and that the trade with China reached its greatest height in the 18th and early 19th centuries. But without such a beginning little interest would have been stimulated for Chinese porcelain, and by the end of the 19th century the later Chinese wares were in great variety in the few large collections.

By the beginning of the present century people were beginning to look back beyond the 17th century to discover what the Chinese were making in much earlier times. The Chinese books, often inaccurately, describe earlier wares going back to the Han (206BC–221AD) and T'ang (618–906AD), and even more important to the classic age of the Sung (960–1279AD). This last dynastic period was that during which the emperors for the first time not only made their taste well-known, but also began to acquire particular types of material, such as Ting, by purchase from specific kilns. The practice of making purchases in this way once begun was to continue until in the Ming dynasty (1368–1644) there were great numbers of 'official' kilns, supplying not only the palace, but the government as a whole. The culmination of this process came in 1683 under the Ch'ing dynasty, when the emperor K'ang-hsi established an imperial kiln under the supervision of a superintendent appointed by himself personally.

There are good examples of this period in the collection, and they are among the earliest acquisitions. Of much earlier date are a number of good quality stonewares of the first century AD from kilns in the far south. The glazes on these pieces are rather imperfect, partly as the result of inexperience on the part of the potters, but also as a result of burial in adverse conditions. The pieces themselves are well proportioned and constructed, and are good examples of a type of stoneware recently identified as having come from the vicinity of Canton.

Earthenware figures intended for burial in the tombs of the wealthy reflect one aspect of ceramic production during the following centuries. Among these the warriors and horses are the most typical.

The classic age of Sung is represented by some excellent small Lung-ch'üan celadons, black glazed wares from Chien in the province of Fukien, as well as others from the kilns of north China, and a few simple bowls from Chi-chou. Of particular interest, however, is the splendid painted pillow of Tz'û-chou type made at the Chang Family kilns in the province of Hopei. All these are stonewares, the true porcelains of the period being represented by some fine small pieces of *ch'ing-pai* from Ching-tê Chên, where the emperor K'ang-hsi was six centuries later to establish his imperial kiln at the centre of the greatest porcelain making region in the world.

Margaret Medley
London, 1980

9

Chronology

Chronology of Chinese Dynasties and periods

Neolithic	Not later than 5th millenium BC–c.1700BC
Shang	c.1700–c.1028BC
Western Zhou (Chou)	c.1027–771BC
Eastern Zhou (Chou) Spring and Autumn Annals	722–481BC
Warring States	481–221BC
Qin (Ch'in)	221–206BC
Western Han	206–12BC
Xin (Hsin)	12–23AD
Eastern Han	25–221AD
Three Kingdoms and Western Jin (Chin)	219–316AD
Eastern Jin and Five Principalities	317–419AD
Nanbeichao I (Nan-pei-Ch'ao I)	420–500AD
Nanbeichao II (Nan-pei-Ch'ao II)	501–580AD
Sui	581–618AD
Tang (T'ang)	618–906AD
Five Dynasties	907–960AD
Liao	907–1125AD
Song (Sung) Northern Song (Sung)	960–1127AD
Southern Song (Sung)	1128–1279AD
Jin (Chin) Tartars	1115–1234AD
Yuan (Yüan) Mongols	1260–1368AD
Ming	1368–1644AD
Hongwu (Hung-wu)	1368–1398AD
Jianwen (Chieh wên)	1399–1402AD
Yongle (Yung-lo)	1403–1424AD
Xuande (Hsüan-tê)	1426–1435AD
Zhengtong (Chêng-t'ung)	1436–1449AD
Jingtai (Ching-t'ai)	1450–1457AD
Tianshun (T'ien-shun)	1457–1464AD
Chenghua (Ch'êng-hua)	1465–1487AD
Hongzhi (Hung-chih)	1488–1505AD
Zhengde (Chêng-tê)	1506–1521AD
Jiajing (Chia-ching)	1522–1566AD
Longqing (Lung-ch'ing)	1567–1572AD
Wanli (Wan-li)	1573–1619AD
Taichang (T'ai-ch'ang)	1620AD
Tianqi (T'ien-ch'i)	1621–1627AD
Chongzheng (Ch'ung-chêng)	1628–1643AD
Qing (Ch'ing)	1644–1912AD
Shunzhi (Shun-chih)	1644–1661AD
Kangxi (K'ang-hsi)	1662–1722AD
Yongzheng (Yung-chêng)	1723–1735AD
Qianlong (Ch'ien-lung)	1736–1795AD

Jiaqing (Chia-ch'ing)	1796–1820AD
Daoguang (Tao-kuang)	1821–1850AD
Xianfeng (Hsien-fêng)	1851–1861AD
Tongzhi (T'ung-chih)	1862–1874AD
Guangxu (Kuang-hsü)	1875–1908AD
Zuantong (Hsüan-t'ung)	1909–1912AD
Republic	1912–1949
People's Republic	1949

Note: Transliteration is given first in Pinying, Wade-Giles system where used follows in parenthesis.
Japanese transliteration in the Hepburn system.

Kiln Sites

Key
- ● kilns
- ○ towns
- *italic* district

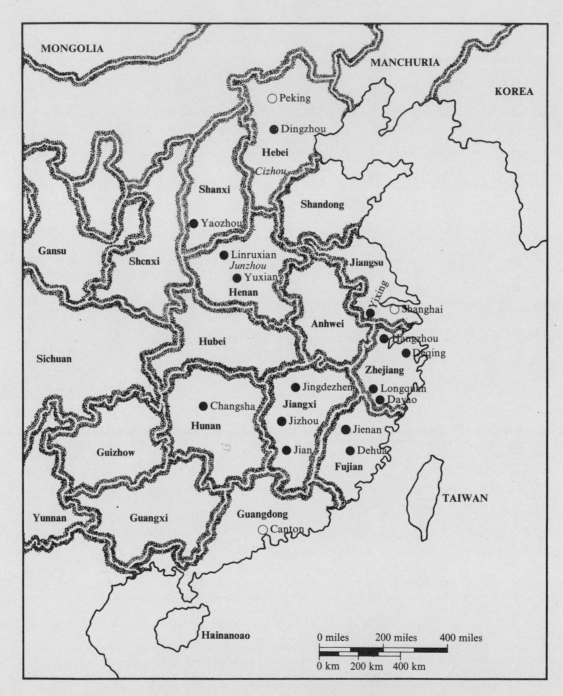

MONGOLIA

MANCHURIA

KOREA

○ Peking

● Dingzhou

Hebei

Cizhou

Shanxi

Shandong

● Yaozhou

Gansu

Shenxi

● Linruxian
Junzhou
● Yuxian

Henan

Jiangsu

Yixing

Anhwei

○ Shanghai

● Hangzhou

● Deqing

Hubei

Zhejiang

Sichuan

● Jingdezhen

● Longquan
● Dayao

● Changsha

Jiangxi

● Jizhou

● Jienan

Hunan

● Jian

● Dehua

Guizhow

Fujian

TAIWAN

Yunnan

Guangxi

Guangdong

○ Canton

Hainanoao

| 0 miles | 200 miles | 400 miles |

| 0 km | 200 km | 400 km |

Reign Marks

Ming Dynasty			Ch'ing Dynasty		
年製 洪武 Hongwu (Hung-wu) 1368–1398	永樂 (seal) Yongle (Yung-lo) 1403–1424	年製 永樂 Yongle (Yung-lo) 1403–1424	治年製 大清順 (seal) Shunzhi (Shun-chih) 1644–1661	熙年製 大清康 (seal) Kangxi (K'ang-hsi) 1662–1722	正年製 大清雍 (seal) Yongzheng (Yung-chêng) 1723–1735
德年製 大明宣 Xuande (Hsüan-tê) 1426–1435	化年製 大明成 Chenghua (Ch'êng-hua) 1465–1487	治年製 大明弘 Hongzhi (Hung-chih) 1488–1505	隆年製 大清乾 (seal) Qianlong (Ch'ien-lung) 1736–1795	年製 嘉慶 (seal) Jiaqing (Chia-ch'ing) 1796–1820	光年製 大清道 (seal) Daoguang (Tao-kuang) 1821–1850
德年製 大明正 Zhengde (Chêng-tê) 1506–1521	靖年製 大明嘉 Jiajing (Chia-ching) 1522–1566	慶年製 大明隆 Longqing (Lung-ch'ing) 1567–1572	豐年製 大清咸 (seal) Xianfeng (Hsien-fêng) 1851–1861	治年製 大清同 (seal) Tongzhi (T'ung-chih) 1862–1874	緒年製 大清光 (seal) Guangxu (Kuang-hsü) 1875–1908
曆年製 大明萬 Wanli (Wan-li) 1573–1619	啟年製 大明天 Tianqi (T'ien-ch'i) 1621–1627	年製 崇禎 Chongzheng (Ch'ung-chêng) 1628–1643	統年製 大清宣 Zuantong (Hsüan-t'ung) 1909–1912	年製 洪憲 Hongxian (Hung-hsien 1916) (Yüan shih-k'ai)	

The Collection

The Collection of Chinese Ceramics at Merseyside County Museums
This interesting group of Chinese ceramics, part of a large oriental art collection, is a virtually unknown and unpublished part of the collection of the Merseyside County Museums. The objective in producing this study is to present it to those scholars and collectors who are unaware of its existence, and to group in type and chronological order the far ranging wares representative of the Chinese potter.

The Merseyside County Museums, Liverpool were founded in 1851 with the gift of a most remarkable collection of zoological specimens by the 13th Earl of Derby. Later, in 1860, the collections were moved into the present grandiose Victorian building in William Brown Street. The size and scope of the museum were greatly extended and enhanced by the Mayer gift of 1867. Joseph Mayer, who had had his own private museum of Egyptology in Liverpool from 1852, was a successful jeweller and goldsmith with wide-ranging interests in antiquities and the decorative arts. In February 1867 Joseph Mayer wrote to the Corporation offering to present his collection of antiquities and works of art to them in trust for the public. His letter concludes with the comment 'I always had in mind to make the collection as much illustrative of the arts of the differing nations as I could, so as to connect ancient and modern art'.

The genesis of the present collection of Chinese ceramics was a part of Joseph Mayer's donation of 1867, and includes *famille verte* and *famille rose* pieces of the Qing (Ch'ing) dynasty which reflect the taste of that period for more decorative and colourful pieces of porcelain (**107, 115**). Only a small selection of these later wares has been included in this catalogue as this part of the collection numbers over 600 separate items, and it is the aim simply to include here specimens from each of the represented groups. Of these only a small proportion is illustrated.

Very few additions were made to the oriental ceramics collection for just over 70 years. One purchase, however, is worth noting because of its interesting provenance. In 1890 the museum purchased a small bowl which had been found in the wreck *Goteberg* (**104**).

In 1938 the museum received the bequest of Miss Jane Weightman, covering wares from the Han period to the Qing (Ch'ing) dynasty. Of the 90 pieces in the bequest all but a very few are described and illustrated in the present catalogue. This large collection was a most important acquisition containing as it does so many early pieces and including such choice items as a Northern Celadon bowl (**31**). Little documentation has survived with the bequest to show how and when it was put together, but labels on almost half of the pieces show that Miss Weightman bought extensively from Bluett & Sons of London. She was an established customer there over a number of years as from 1928 until shortly before her death she had an account with the firm. Twelve pieces were purchased during this period, including a Celadon bowl (**37**) bought in 1935 for £21 and a tea bowl (**70**) bought in the same year for £4.10s.

In May 1941 the museum building was devastated by fire but most of the collection of Chinese ceramics must have been evacuated because although some important specimens were destroyed the majority of the collection remains intact.

In 1950 the widow of Captain Francis Buckley gave the museum a large number of items from his collection, which is better known for the mesolithic flint tools from the sites in the Pennines, but which did include amongst other oriental material one Han and four Tang dynasty pieces (**1**, **13**, **15**, **17** & **19**). Further additions were made by purchase, mostly of early wares, to extend the scope of the collection. Five archaic pieces, including the model of a House (**10**), were bought from a Mr Meyer in 1953. These pots were said to have been excavated at Changsha in China, and taken to Hong Kong where they were purchased by a friend of Meyer's, R. C. Terry, in 1951 and brought over to England. Terry, a government employee in Hong Kong, returned to England in 1951. In February 1956 he sold three items himself to the museum and in May a further fourteen pieces the most important of which were proto Yue (Yüeh) wares (**25**, **26** & **27**), and the magnificent Cizhou (Tz'ŭ-chou) pillow (**78**).

In the same year the then City of Liverpool Museums acquired the bulk of the foreign collections of Norwich City Museums, and a few of the oriental items in these come within the scope of this catalogue. Of considerable interest are three provincial Chinese pots (**178**, **187**, **188**) collected by Charles Hose in Borneo where he was in the service of the Rajah from 1884 to 1907.

The collection has also been built up by gifts of individual items. In 1957, for example, the Soroptimist Club of Liverpool decided to commemorate their charter year by donating a Tang tomb figure (**16**). This welcome tradition of donations still continues (**190**).

At the present time with the tremendous and continuing increase in prices of quality items coming on to the market, the museum is unable to pursue an active collecting policy. It has been possible, however, to begin building up a group of provincial wares as an extension to the collection, and for comparative purposes.

Although this collection does not follow the taste and work of one individual, being the creation of many donations over more than a century, it does represent the culmination of a long history, and the generosity of the public. It is a balanced blend of fine objects, appealing to the scholar, connoisseur and layman alike. It is hoped that now the collection will take its place among important collections of Chinese ceramics available for the public's pleasure.

Acknowledgements

I would like to thank all those people who have been instrumental in the preparation of this catalogue. I owe a particular debt of gratitude to Miss Margaret Medley for the valuable advice on the dating and attribution of certain pieces, and for her never ceasing interest in the museum collection and this catalogue. I am most grateful to Mr J. C. Yue for his help with translating some of the inscribed characters. I have to thank Mr Peter Windle for his drawings, Dr Stuart Munro-Hay for advice on layout, and especially Mrs Beryl Vickery for her patience and care in typing much of the catalogue. I would like to thank the staff of Liverpool City Libraries, the Director of the Musée Guimet, and Messrs Bluett & Sons of London for information and help.

Among staff and former staff of the Museum, I should like to express my gratitude to Mr Lionel Burman, to Dr Dorothy Downes, who initially allowed me access to the collections, to Mr Colin Pitcher, the Museum Photographer, to Miss Yvonne Schumann, to Mr Edmund Southworth, to Mr Andrew Turner, to Mrs Margaret Warhurst who has edited the catalogue, and to the staff of the Design Department.

Eldon Worrall

1 Han Period and later wares

During the Han period (206BC–220AD) wares were produced both for domestic and funerary use. Forms and decoration generally derive from bronze types and contemporary textile designs. High fired earthenwares were produced in northern Zhejiang (Chekiang) and Guangdong (Kwangtung) provinces, and around Changsha (Ch'ang-Sha) in Hunan province, the latter wares characteristically stained an ochre colour through burial in the soil of that region; an incense burner (**3**) exemplifies this.

Another ware being produced at the same time as these high fired wares was one covered in a low fired lead glaze (**7–11**). The ware was produced specifically for burial with the dead; previously ordinary domestic vessels had been used. Usually copper was added to the glaze to give a rich green colour, very similar to pottery of the same period from the Mediterranean. Indeed, it is not certain whether this lead glaze was a Chinese or Western invention.

Moulded decoration was a most important innovation of this period, often adding an exciting element to what would otherwise be a rather lifeless pot. Numbers **5**, **9**, **11** and **12** are decorated in this way.

It was the custom to include pottery figures amongst tomb furnishings, and there were strict regulations governing the size allocated to each rank. Generally tomb figures of the Han period were not glazed but were decorated with bright pigments over a grey black fabric. The only example of such a tomb model in the collection is of a horse (**1**), a spirited, lively piece of sculpture.

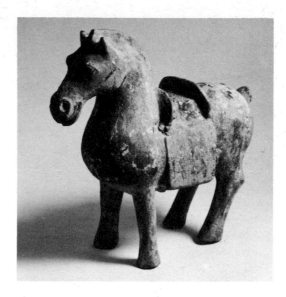

1 Unglazed model of a horse
An unglazed grey pottery figure of a horse, saddled, and with indications of harness painted in black over a white slip; a horn-like protuberance to the skull; the tail and the left rear leg broken. (Horses of this type generally bore detachable riders with legs apart.)
h. 28·5 cm, l. 31·5 cm
Unglazed earthenware
North China
Han Period (206BC–220AD)
50.137.4
Given by Mrs Buckley, 1950
cf Jansen (1976) p.38 no.26
 Koyama (1955) vol.8 pl.106

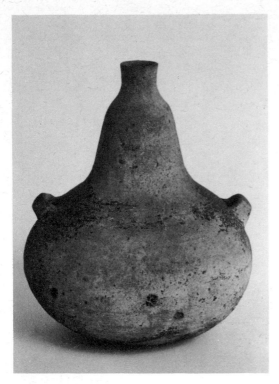

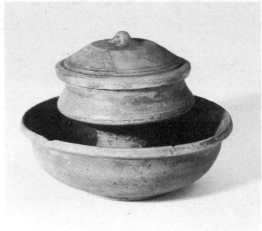

2 Pilgrim flask
A gourd-shaped finely potted vessel of grey
earthenware, the shoulders with two horizontal
loop handles; covered overall with the
fragmentary remains of a dark brown potash
glaze; the foot rim wire cut, and with two wedge
shaped marks.
h. 18 cm
High fired earthenware
Guangdong (Kwangtung) province
Later Han Period
Han Period (206BC–220AD)
56.39.8
Bought from R. C. Terry, 1956
cf Newton (1950) p.27

3 Incense burner
A thickly potted incense burner and cover of buff
earthenware, the lid with a central loop handle
and incised lines running round the edge; covered
with a light green opalescent glaze, partially
decomposed through burial.
h. 12·7 cm, d. 16·8 cm
High fired earthenware
Changsha (Ch'ang-Sha) region
Hunan province
3rd century AD
Han Period (206BC–220AD)
53.1.3
Bought from S. B. Meyer, 1953
cf Newton (1950) pl.5f

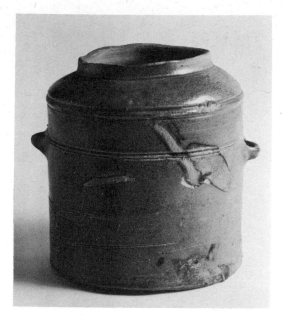

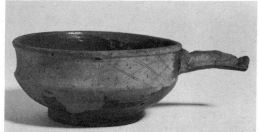

4 Storage jar
A jar of pink stoneware with two horizontal loop
handles, two bands of incised line decoration
running around the body; the base wire cut and
impressed with two wedge shaped stilt marks; the
outside covered in a brown glaze splashed with
green.
h. 15 cm, d. 9·5 cm
Alkaline-glazed stoneware
Changsha (Ch'ang-Sha) region
Hunan province
Han Period (206BC–220AD)
53.1.4
Bought from S. B. Meyer, 1953
cf Newton (1950) p.30
Note: Similar pieces have been discovered in
Annam, which was invaded by the Han in 111BC,
and was for a long time under their control.

5 Dipper
A dipper of pink stoneware, the upper part of the
bowl concave in section and decorated with an
incised diamond motif; the handle horizontal and
moulded as a dragon head; the base flat. The
whole vessel is covered in a brownish green
alkaline glaze partly flaked.
h. 8·2 cm, l. 26 cm
Alkaline-glazed stoneware
Guangdong (Kwangtung) province
Han Period (206BC–220AD)
53.1.5
Bought from S. B. Meyer, 1953
cf Beurdeley (1974) p.59

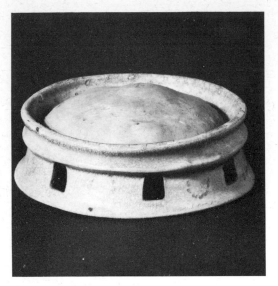 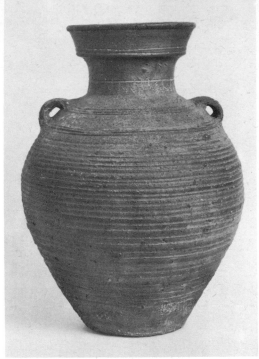

6 Pot stand
A stand of reddish brown stoneware, the foot
pierced with seven rounded windows with incised
rosettes between; covered in a yellow-green
alkaline glaze, finely crackled and forming drops
running down over the surface; the convex top
unglazed and surrounded by a ledge.
h. 6 cm, d. 18·25 cm
Alkaline-glazed stoneware
Changsha (Ch'ang-Sha) region
Hunan province
5–6th centuries AD
Six Dynasties (221–589AD)
53.1.2
Bought from S. B. Meyer, 1953
cf Beurdeley (1974) pl.63 & p.107
 Koyama (1956) pl.82

7 Vase
Vase of dark grey stoneware, the neck decorated
with a band of wavy lines drawn with a comb, the
body with incised lines, the shoulders having
vertical strap handles; covered overall in a dark
brown slip bubbled by the heat of firing.
h. 33 cm
Glazed stoneware
Anhui (Anhwei) province or
Jiangsu (Kiangsu) province
Later Han Period
Han Period (206BC–220AD)
56.39.6
Bought from R. C. Terry, 1956
cf Hochstadter (1953) pl.29 no.113
 Karlbeck (1949) p.34–35 & pl.IId

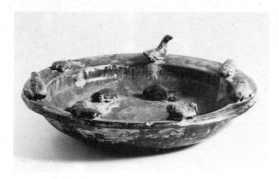

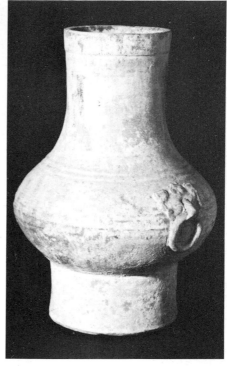

8 Model of a pond
A flat bottomed dish with rounded sides and ledge
rim, of pinkish earthenware; decorated in high
relief with two ducks, two tortoises, and three
toads around the rim, the well with three carp,
two tortoises and a toad, all in positions as if
partly submerged in water; covered in a green-
yellow lead glaze running over the outside walls
and onto the flat base, but leaving the central area
of the base unglazed. The interior of the dish has
patches of silvery iridescence.
d. 33 cm
Green lead-glazed red earthenware
North China
Han Period (206BC–220AD)
56.39.7
Bought from R. C. Terry, 1956
cf Tokyo National Museum (1953) pl.4

9 Vase
A vase of light reddish earthenware imitating the
form of a bronze vase type; decorated with
moulded ring handles in relief, and with two sets
of triple moulded bands on the body; the neck
with a collar in relief; covered with a dark green
glaze showing some decomposition from burial.
There are three wedge-shaped marks on the base.
h. 35·5 cm, d. 27·3 cm
Green lead glazed earthenware
North China
Han Period (206BC–220AD)
56.39.5
Bought from R. C. Terry, 1956
cf University of Michigan (1965) pl.1
an unpublished vase in the Musée Guimet,
 Paris (M6 29143)

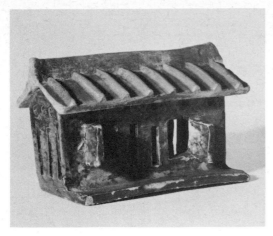

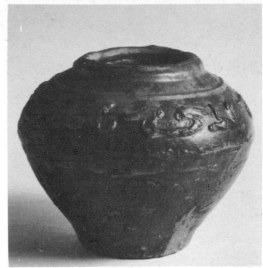

10 Model of a house
A thickly potted red earthenware model of a
house with separate roof. The model is rectangular
in shape with pierced rectangular and circular
windows, and a ribbed roof; covered in a green
lead glaze. The glaze on the roof is partly shed.
h. 15 cm including roof, l. 22 cm
Green lead glazed red earthenware
North China
Han Period (206BC–220AD)
53.1.1
Bought from S. B. Meyer, 1953
cf Admin Comm (1978) pl.34 for the dating of a
 similar house in bronze

11 Jar
A thickly potted small jar of pink earthenware,
the rounded shoulders set with a small rim, and
decorated with a continuous moulded panel,
contained within two parallel lines, depicting four
hydra pursued by four lions; covered overall in a
dark green lead glaze, iridescent in patches, the
interior unglazed; fired upside down on the rim.
h. 13·5 cm, d. 16·5 cm
Green lead glazed earthenware
North China
Han Period (206BC–220AD)
38.117.1
Bequest of Miss Weightman, 1938
cf Laufer (1909) p.135 & pl.34 fig. 1 and 2
Note: this moulded decoration is discussed by
Fenollosa (1912, 23)

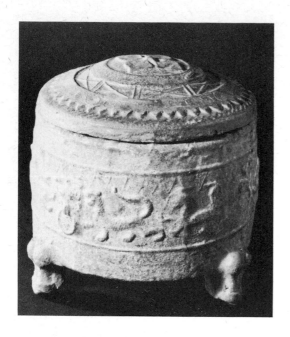

12 Cosmetic box and lid
A thickly potted light reddish earthenware vessel
imitating the form of a bronze vessel called *lien*;
the sides moulded in relief with a procession of
animals consisting on one side of a tiger, a
dancing bear, a monkey, a wave or hill, a
hippopotamus and a dragon, and on the other side
of a tiger, a horse, a wave or hill, a lion and a
dragon separated by Taotieh (Tao-Tieh) masks,
with a zigzag line above and all contained within
two parallel lines encircling the vessel. The lid is
decorated with a central motif representing a
quatrefoil flower. The three feet are in the form of
animal heads. The exterior of the box and lid are
covered in a green lead glaze. Moulded marks are
visible on the exterior.
h. 18 cm including lid, d. 21 cm
Green lead glazed red earthenware
North China
Han Period (206BC–220AD)
56.39.1
Bought from R. C. Terry, 1956
cf Laufer (1909) p.210 & pl.LVIII No.2

2 Tang (T'ang) Dynasty wares

This has long been regarded as the great sculptural period in the history of Chinese ceramics although certain recent excavations including those in progress at Qin shin huangdi (Ch'in Shin Huang-ti) near Sian, have produced pottery figures which show that outstanding sculptural works were also made during the Han period.

The Sui and Tang (T'ang) dynasties developed an economic and political stability in the state, broadening the contacts, improving the communications and establishing powerful central control. The expansion of the Tang state along the Silk route to the west, and the attendant influx of foreign ideas and materials, lent a new zest to the arts of the period. The Chinese ability to absorb and utilise new ideas on their own terms is admirably demonstrated. Paintings, metalwork and even the western Asian style garments of the tomb figures reflect the alterations of style that this energetic period produced as western influences gained ground (**14**, **15**, **17** and **19**).

During this period stoneware came to replace earthenware, and of the many technical improvements and inventions which took place the evolution of porcelain was the most important, an invention which has become synonymous with the name of China. Decoration was varied: moulded decoration could be applied on to a vessel (**20**) or, less commonly, incised decoration in the form of stylised leaf motifs was used (**21**). Lead glazes were again used but now often applied over a white slip on a whitish finely-grained body, in contrast to the pink body of Han period examples. The earliest of the Tang dynasty glazes were almost colourless, most often with a pale straw yellow tone, caused by the presence of iron (**14–19**). They frequently appear crackled.

One of the important inventions of the Tang period was the three-colour, low-fired glazing technique known as Sancai (San-t'sai). This achieved great richness of effect, streaks of viscous glaze being allowed to run down the body from top to bottom (**24**). These wares were made mainly at kilns in the provinces of Shensi and Honan in the north of China.

Tang tomb figures were produced in the north of China and generally differ from Han figures in that they combine vitality and energy with a sense of realism. Very often the figures were produced from moulds, the marks of which are sometimes visible. **14** exhibits this quite clearly with the marks running vertically up each side of the figure. The bellies of the horse models are generally cut out, as with **19**, the figure of a horse and rider.

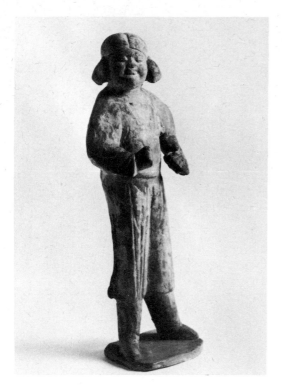

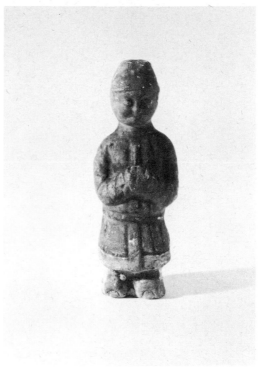

13 Figure of an actor
Unglazed study of an actor with clenched fists, wearing a cap, the robes with an open collar, and slightly padded arms, the body of red earthenware, bearing traces of white pigment; broken at the waist.
h. 29·5 cm
Unglazed funerary ware
North China
Tang (T'ang) Dynasty (618–906AD)
50.137.7
Given by Mrs Buckley, 1950
Ex J. R. Creagh
cf Hobson (1948) p.14 fig.21

14 Figure of a groom
Hollow moulded white-buff earthenware figure of a groom wearing a tunic and belt; covered in a clear glaze now degraded, with unfired painted decoration, the eyebrows and curled moustache black, the edges of the robe red. The figure probably represents a Middle Eastern groom.
h. 12·25 cm
Glazed white/buff earthenware
North China
Early Tang (T'ang) Dynasty (618–906AD)
1978.361.24
Source not known

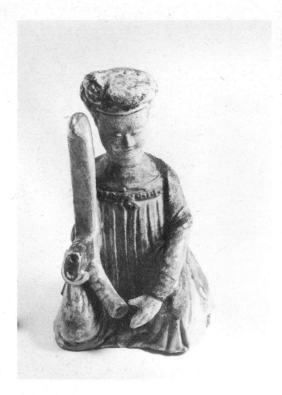

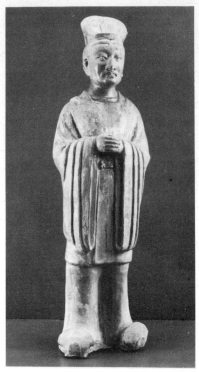

15 Kneeling figure of a musician
Hollow moulded buff earthenware figure of a
woman wearing a stole and a pleated dress, and
holding in her left hand a musical instrument;
covered in a straw coloured lead glaze, with
unfired painted decoration in red and black, the
eyes, mouth and eyebrows finely painted.
h. 13 cm
Glazed buff earthenware
Tang (T'ang) Dynasty (618–906AD) and modern
50.137.5
Given by Mrs Buckley, 1950
Note: Although the body of this figure is
comparatively recent in date, the head dates from
the Tang (T'ang' dynasty.

16 Figure of a man
Light hollow moulded buff earthenware tomb
figure of a court official wearing military-type
dress and shoes with cloud-form toes, the belted
robe with long pleated sleeves, hands clasped as if
to take a pole banner; covered in a pale sulphur
translucent glaze, with some traces of unfired
painted decoration in blue, red and black; broken
at the neck.
h. 64 cm
Glazed white buff earthenware
North China
Tang (T'ang) Dynasty (618–906AD)
57.120
Given by the Soroptomist Club of Liverpool, 1957
cf Ridley (1973) pl.21 & pl.1

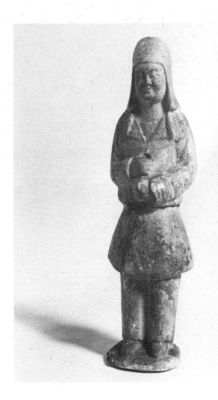 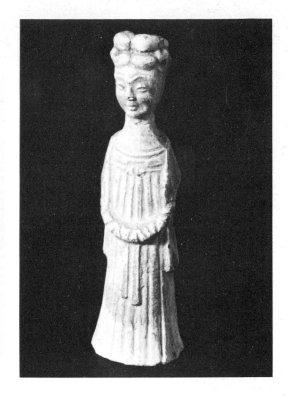

17 Figure of a warrior
Hollow moulded white earthenware figure of a
standing man, wearing a belted tunic with lapels;
covered overall in a straw coloured glaze.
h. 20 cm
Glazed buff/white earthenware
North China
Tang (T'ang) Dynasty (618–906AD)
50.137.6
Given by Mrs Buckley, 1950
cf Joseph *et al.* (1970) pl.1

18 Figure of a woman
Hollow moulded light buff earthenware figure of a
lady wearing a stole, and a pleated dress; covered
in a straw coloured glaze, with traces of red
unfired painted decoration around the hem of the
dress.
h. 13·5 cm
Glazed buff earthenware
North China
Tang (T'ang) Dynasty (618–906AD)
48.11
Given by Mr & Mrs Lloyd, 1948
Given to Mr & Mrs Lloyd on a visit to China
before 1926

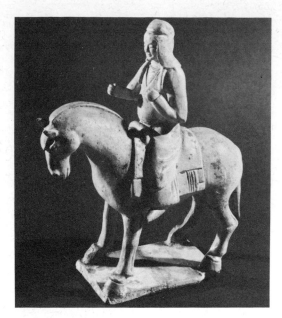

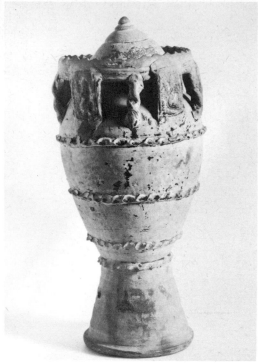

19 Horse and rider
A buff earthenware figure of a horse and rider, the
rider wearing a costume of central Asian type, the
belly of the horse cut out in typical fashion;
covered in a cream glaze partly decomposed
through burial.
h. 23·5 cm
Glazed buff earthenware
North China
Tang (T'ang) Dynasty (618–906AD)
50.137.8
Gift of Mrs Buckley, 1950

20 Funerary urn
A crudely potted buff earthenware urn, with a lid
of conical form, body decorated with four bands
of pie-crust pinched decoration, the shoulder
decorated with five wide straps raised from the
shoulder and with a joining band; the straps each
decorated with a moulded figure study, reflecting
Buddhist influences. A few fragments of the ill-
fitting brown glaze still adhere to the body.
d. 20·5 cm, h. 60 cm including lid
Glazed buff earthenware
Tang (T'ang) Dynasty (618–906AD) or later
56.39.13
Bought from R. C. Terry, 1956
cf Sweetman (1966) pl.6

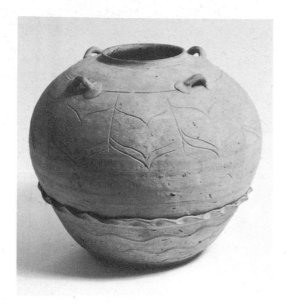
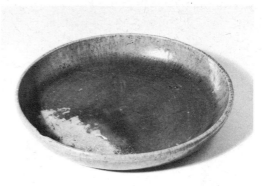

21 Globular vase
A finely potted buff earthenware globular vase
with an applied strip of pie-crust decoration
around the lower body and four horizontal lugs
around the shoulder; the upper part of the body
with incised decoration representing stylised leaf
motifs, the lower with three incised wavy lines.
Remnants of the ill-fitting dark brown alkali glaze
still adhere.
h. 23 cm, d. 25 cm
Glazed buff earthenware
North China
Early Tang Dynasty
Tang Dynasty (618–906AD)
56.39.12
Bought from R. C. Terry, 1956

22 Flat dish
A small thinly potted shallow dish of finely
grained white earthenware, with rounded sides
and a flat base; covered in a light to dark olive-
green glaze which has run on the base but leaving
a central area unglazed. The interior of the dish
has a patch of iridescence.
d. 14·6 cm
Glazed buff earthenware
North China
Tang (T'ang) Dynasty (618–906AD)
38.117.2
Bequest of Miss Weightman, 1938
Bought from Bluett & Sons

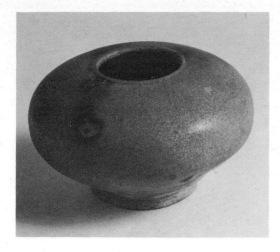

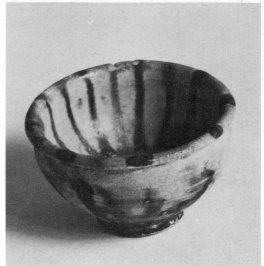

23 Water pot
A finely grained buff earthenware globular vase,
covered in a light green translucent glaze, and
decorated around the mouth with three darker
green splashes; the glaze finely crazed overall; the
base unglazed.
d. 8 cm, h. 4·5 cm
Glazed buff earthenware
Probably from Sian, Shenxi province
North China
Tang (T'ang) Dynasty (618–906AD)
38.117.49
Bequest of Miss Weightman, 1938

24 Ceremonial wine cup
A wine cup of finely grained whitish buff
earthenware, the lip everted and the rounded body
tapering to a small foot; covered in a green, brown
and yellow glaze continuing over the foot.
h. 4 cm, d. 6 cm
Whitish buff glazed earthenware
North China
Tang (T'ang) Dynasty (618–906AD)
38.117.3
Bequest of Miss Weightman, 1938
cf Koyama (1956) vol.9 fig.103
Note: This would originally have belonged to a
set of cups with its own tray.

3 Proto Yue (Yüeh) wares

The name Yue was first applied to this type of ware by the Chinese sometime in the Tang (T'ang) period. The name comes from that of the ancient kingdom where the kilns producing this type of ware were situated. The kilns producing Yue and the earlier Proto Yue wares lay south of the Yangtse river in an area stretching from Deqing (Tê-Ch'ing) through Hangzhou (Hang-Chou) and Shaoxing (Shao-hsing) to Youyao (Yü-yao). The fabric was usually a grey coloured stoneware on which various types of decoration were used. The most popular of these were pecked decoration made by a needle (26), separately moulded decoration (26), and rouletted decoration (27). The glaze on this class of wares, coloured by the presence of iron oxide, varies from shades of brownish yellow to grey-green, depending on the firing. Inconsistencies in glaze thickness are common. Compare the incense burner (28) which is thickly glazed with the vase (27) which is thinly glazed.

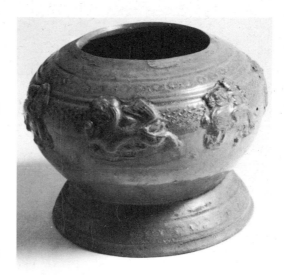

25 Urn on foot
A globular urn of grey stoneware on high foot, the base slightly concave; the body decorated with six moulded motifs, depicting alternately Chimera and mounted horsemen, applied over a band of rouletted diaper pattern, with a band of rouletted rosette pattern above and another around foot; covered in a grey glaze. The horse has a hook-like projection on its chest and a spiral on its hind quarters. The neck of this urn appears to have been removed.
h. 10 cm, d. 13·5 cm
Proto Yue (Proto-Yüeh) ware
probably from Jiuyan (Chiu-yuan) kiln
Zhejiang (Chekiang) province
3rd century AD
Western Jin (Chin) (265–316AD)
56.39.2
Bought from R. C. Terry, 1956
cf Karlbeck (1949) p.41–42

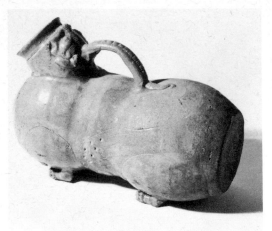 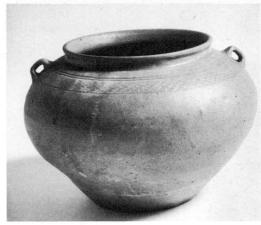

26 Urinal

A urinal of grey stoneware in the form of a lion
with separately cast feet wearing a type of sandal;
decorated at the mouth with a separately moulded
mask of a lion's head, the moulded handle
representing its mane, incised lines outlining the
muscles and peck marks indicating the fur;
covered in a grey green glaze degraded in parts.
h. 18·5 cm, l. 26 cm
Proto Yue (Proto-Yüeh) ware
Jiuyuon (Chiu-yuan) type
Zhejiang (Chekiang) province
3rd century AD
Western Jin (Chin) (265–316AD)
56.39.9
Bought from R. C. Terry, 1956
cf Karlbeck (1949) pl.15

27 Small vase

A vase of grey stoneware with concave base and
rounded sides, decorated below the collar with a
band of rouletted diaper motif, partially concealed
by two vertical lugs; covered in a light green
translucent glaze.
h. 13 cm, d. 10·8 cm
Proto Yue (Yüeh) ware
Zhejiang (Chekiang) province
3rd century AD
Western Jin (Chin) (265–316AD)
56.39.10
Bought from R. C. Terry, 1956
cf Karlbeck (1949) p.33

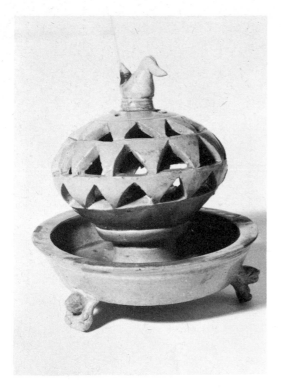

28 Incense burner

An incense burner of grey stoneware, the three
moulded feet in the form of bears holding up a
shallow dish, with a hollow pillar supporting a
container decorated by cut out triangles and on
one side a small door, the whole surmounted by
the figure of a duck; covered in a grey-green
glaze.

h. 15·5 cm, d. 11 cm
Proto Yue (Yüeh) ware
Zhejiang (Chekiang) province
Late 3rd century AD
Western Jin (Chin) (265–316AD)
56.39.11
Bought from R. C. Terry, 1956
cf Addis (1978) pl.5a

4 Northern Celadon wares

Until the 1940s this ware was largely ignored but more recently its importance has been recognised. It was produced at a number of kilns in north China including Linruxian (Lin-Ju Hsien) and Yaozhou (Yao-Chou). There are problems in ascribing with any certainty material to either of these two kilns as the body material is similar, and similar decorative motifs were used at both centres. There is little archaeological data by which to make certain judgement so it is not possible to provide details of the kilns for the examples in this section of the catalogue.

The body is usually grey or brownish and the transparent glaze varies from an olive green to an olive colour. A glaze with a yellowish tone is considered a characteristic of pieces of lesser quality.

Carved decoration was employed to good effect, the glaze pooling in the carved lines (**29** and **31**). Moulded decoration was introduced sometime at the beginning of the 12th century (**30**). Production of this ware apparently ceased after 1127 when the capital moved south to Hangzhou (Hang-Chou).

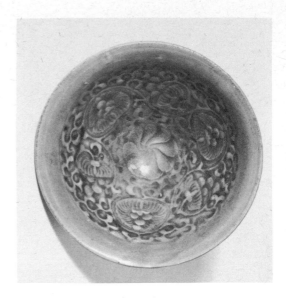

29 Stoneware bowl

A thickly potted grey stoneware bowl conical in form with a flared rim, and a small base; the interior carved with a design of a conventionalised flower and sickle-leaf scrolls, the exterior carved with a band of pleating; covered in an olive-green glaze.

d. 10 cm, h. 4·3 cm
Northern Celadon ware
11th–12th century
Northern Song (Sung) Dynasty (960–1127AD)
38.117.46
Bequest of Miss Weightman, 1938
Bought from Bluett & Sons
cf Wirgin (1979) pl.2c
 Yao Tz`u T`u Lu (1956) part 1 pls. 13 & 17

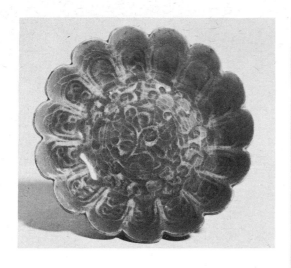

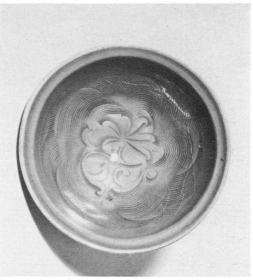

30 Small dish
A thinly potted grey porcellanous stoneware dish,
the sides composed of fifteen lobes; the interior
decorated with a moulded design of a lotus
flower in the centre surrounded by a band of
flowers; covered in an olive-green glaze crackled
overall, the base unglazed and recessed.
d. 9·8 cm
Northern Celadon ware
12th–13th century
Song (Sung) Dynasty (960–1279AD)
38.117.47
Bequest of Miss Weightman, 1938
cf Wirgin (1979) pl.5g

31 Bowl
A thickly potted grey stoneware bowl with
rounded sides and flared rim; the interior, except
for a plain band near the rim, decorated with a
carved lotus spray and two lotus leaves
surrounded by a combed ground of waved
pattern; covered in an olive-green glaze, the
square cut foot and the base both unglazed.
d. 13·7 cm
Northern Celadon ware
12th century
Jin (Chin) Dynasty (1115–1234AD)
38.117.45
Bequest of Miss Weightman, 1938
cf Hobson (1925–28) vol.II, pl.liv, B.192
 Sullivan (1963) pl.66a
 Wirgin (1979) pl.8,1

5 Guan (Kuan) ware

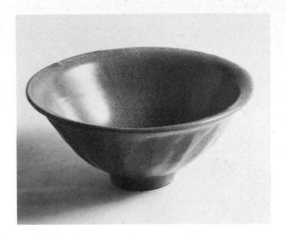

It is not certain where this type of ware was manufactured, although according to tradition the Imperial Household ordered the Department of Buildings to set up production in the palace precincts at Hangzhou (Hang-Chou). The site has not been located. In 1929 the Altar of Heaven kiln (Jiaotan) on which knowledge of the ware is based was discovered but unsystematically excavated. The ware is divided into three classes according to the type of glaze. The finest quality is pale grey-blue in colour, widely crackled over a very fine black body; the second is duller and greener in colour, and more closely crackled over a black body; the third is pale grey brown in colour, and closely crackled over a dark grey body. **32** belongs to the third group.

The crackled glaze which was much admired by the imperial court probably was in origin an unintentional firing mishap. A very similar ware was produced further south in the region of Longquan (Lüng-Ch'üan) at Dayao (Ta-Yao) and at Qikao (Ch'i-K'ao). This scarce ware from the two kilns is virtually undistinguishable from the Guan ware excavated at the Altar of Heaven kiln.

32 Small bowl
A bowl with a somewhat out-turned lip, the outside moulded with stiff leaves; the fine body oxidised brown-red at the exposed foot; covered in a thick grey glaze, crackled light brown all over.
d. 10·8 cm, h. 4·8 cm
Probably Guan (Kuan) ware
Probably 13th century
Song (Sung) Dynasty (960–1279AD)
38.117.30
Bequest of Miss Weightman, 1938

6 Southern Celadon wares

The name celadon comes from D'Urfe's pastoral romance L'Astrée in which the shepherd Celadon wore ribbons of a soft grey-green colour. It is used to describe greyish or brown bodied wares covered with an olive-green or grey-green glaze. At the present time the term is applied to Yue (Yüeh) ware and Longquan (Lung-Ch'uan) ware as well as the northern celadon wares, but it is the southern celadon wares which are the best known. This is because they, unlike the northern celadon wares, were widely exported. In Japan a type of celadon which came to be known as Kinuta (literally, mallet vase) was especially prized for the colour and tone of the glaze. In the middle eastern countries celadon was much sought after because it was held to have the magical power of detecting poisons by changing colour.

There is insufficient data available to allow the attribution of wares to particular kilns so that it is only possible to group the southern celadon wares very generally. They were produced over a very long period of time from the Song (Sung) dynasty to the later part of the Ming dynasty. **33** and **34** are very early examples of this ware and bear a close resemblance to Proto-yue wares. **25** to **28**

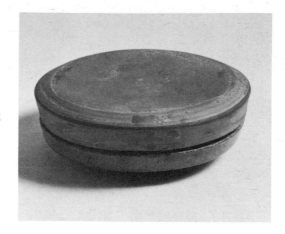

33 Cosmetic box
A grey stoneware circular box with tapered sides and a flat cover, the base concave; covered in a grey-blue celadon glaze, somewhat degraded.
d. 9·8 cm
Southern Celadon ware
Probably Zhejiang (Chekiang) province
11th–12th century
Song (Sung) Dynasty (966–1279AD)
56.39.17
Bought from R. C. Terry, 1956
cf Ayers (1964) vol.2, p.82, pl.LIII

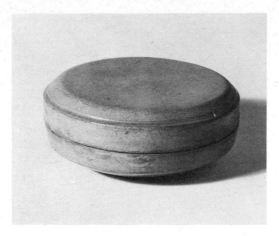

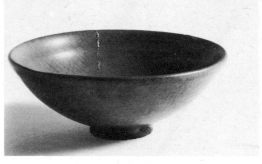

34 Cosmetic box
A grey stoneware cosmetic box with flattened lid
covered in a grey-blue celadon glaze.
d. 9·5 cm
Southern Celadon ware
Probably Zhejiang (Chekiang) province
11th–12th century
Song (Sung) Dynasty (966–1279AD)
56.39.16
Bought from R. C. Terry, 1956

35 Small bowl
A grey stoneware bowl of conical form with
slightly bevelled foot; covered in a thin sage-green
celadon glaze stopping short of the footring in an
uneven line; the glaze heavily crackled all over in
imitation of Guan ware, and containing palm
eyes; the base glazed, the footring oxidised an
orange-brown colour. The rim is chipped in two
places and cracked.
d. 12·5 cm, h. 4·8 cm
Southern Celadon ware
Probably Zhejiang (Chekiang) province
12th century
Song (Sung) Dynasty (966–1279AD)
38.117.29
Bequest of Miss Weightman, 1938

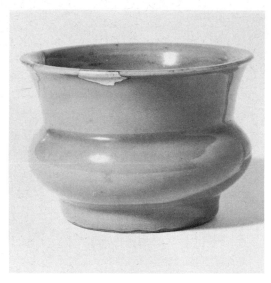

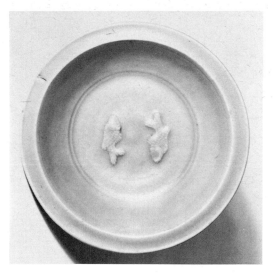

36 Leys jar
A grey-white porcelain bowl with everted rim and rounded sides, covered in a fine blue-green celadon glaze; the base glazed and the footrim oxidised red. The lip has been repaired with gold lacquer.
d. 13·2 cm, h. 9·5 cm
Southern Celadon ware
Probably Zhejiang (Chekiang) province
11–13th century
Song (Sung) Dynasty (966–1279AD)
38.117.32
Bequest of Miss Weightman, 1938
Bought from Bluett & Sons

37 Bowl
A bowl of grey-white stoneware with flattened everted lip; the interior decorated with two moulded opposite-facing carp symbolising conjugal felicity, the exterior with moulded decoration of stylised leaves in a continuous band; covered in a jade-green celadon glaze, the footrim unglazed and oxidised red. The mouth rim is chipped and has a large firing crack.
d. 12·8 cm
Southern Celadon ware
Probably Zhejiang (Chekiang) province
13th century
Song (Sung) Dynasty (966–1279AD)
38.117.24
Bequest of Miss Weightman, 1938
Bought from Bluett & Sons
cf Gompertz (1958) pl.15
 Legeza (1972) pl.xxxii
 Sullivan (1963) pl.84g

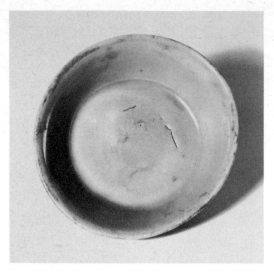
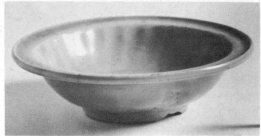

38 Shallow dish
A dish with straight sides of porcellanous
stoneware, the inside of the bowl incised with a
peony flower; covered in a sea-green celadon
glaze, the base partly unglazed and oxidised
orange, the footring glazed.
d. 11 cm
Southern Celadon ware
Probably Zhejiang (Chekiang) province
11th–13th century
Song (Sung) Dynasty (966–1279AD)
38.117.22
Bequest of Miss Weightman, 1938
Bought from Bluett & Sons

39 Shallow dish
A small shallow dish of whitish finely grained
stoneware with a flattened everted rim; the
interior has a moulded ribbed decoration to the
sides; the footrim has been knife pared; covered
in a blue-green celadon glaze. This piece is a kiln
waster, with part of another dish attached to the
base.
d. 12·5 cm
Southern Celadon ware
Probably Zhejiang (Chekiang) province
12th–13th century
Song (Sung) Dynasty (966–1279AD)
38.117.21
Bequest of Miss Weightman, 1938
Bought from Bluett & Sons

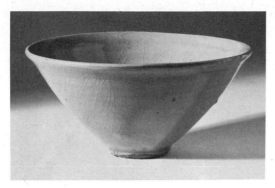 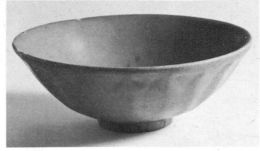

40 Conical bowl
A porcellanous stoneware bowl with slightly
upturned lip; covered in a crackled sage-green
celadon glaze, with an unglazed patch on the rim,
the footring unglazed and oxidised brown.
d. 14 cm
Southern Celadon ware
Probably Zhejiang (Chekiang) province
11th–13th century
Song (Sung) Dynasty (966–1279AD)
38.117.28
Bequest of Miss Weightman, 1938
Bought from Bluett & Sons

41 Bowl
A thickly potted conical bowl of fine-grained
stoneware, the body of greyish colour with
rounded sides; the exterior carved with lotus
petals; covered in a waxy greenish celadon glaze,
the base partially unglazed and oxidised brown in
parts. The mouth rim is slightly chipped.
d. 16·3 cm
Southern Celadon ware
Probably Zhejiang (Chekiang) province
12th–13th century
Song (Sung) Dynasty (966–1279AD)
38.117.26
Bequest of Miss Weightman, 1938

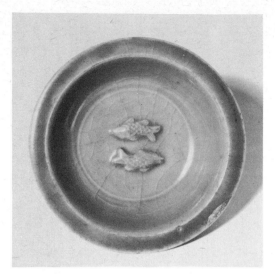

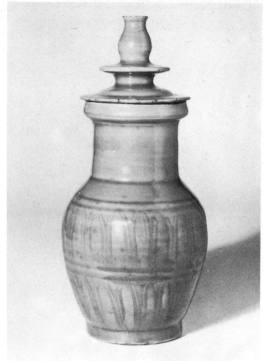

42 Shallow bowl
Stoneware bowl with ledge rim of a white-grey
body, with slightly rounded sides; the centre
decorated with two moulded fish symbolising
conjugal felicity, the exterior with carved lotus
petals; covered in a dark grey-green celadon
glaze, the flat base glazed and the footrim tapered
and oxidised red, crackled overall. The rim has
been repaired.
d. 13·5 cm
Southern Celadon ware
Probably Zhejiang (Chekiang) province
12th–13th century
Song (Sung) Dynasty (966–1279AD)
38.117.23
Bequest of Miss Weightman, 1938

43 Vase and lid
A bottle-shaped vase and lid of whitish-grey
porcelain, with tall cylindrical neck and projecting
lip; the body decorated with two bands of stylised
leaves; covered with a greenish-grey celadon
glaze; the unglazed foot rim and base burnt a light
orange. The lid is in the form of two discs.
h. 26 cm incl. lid
Probably Zhejiang (Chekiang) province
13th century
Late Song (Sung) Dynasty (960–1279AD)
38.117.41 and 42
Bequest of Miss Weightman, 1938

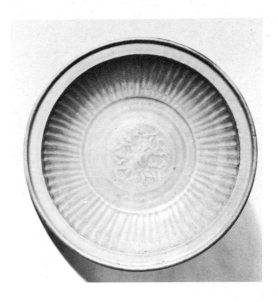

44 Four sherds

a) body sherd; fine, white buff body, carved petal decoration under matt green glaze.
4·5 × 4·2 cm
49.62.72

b) sherd from base of bowl; grey body, carved decoration under thick pale green-grey glaze.
6 × 4·5 cm
49.62.74

c) sherd from base of bowl; fine, grey body, carved decoration under green glaze.
4 × 5·5 cm
49.62.75

d) body sherd from lotus bowl; grey body, carved decoration under thick olive green patchy glaze.
5 × 4 cm
49.62.76

Southern Celadon ware
Probably Zhejiang (Chekiang) province
Song (Sung) Dynasty (960–1279AD)
Given by Mrs Newberry, 1949
ex collection Professor P. E. Newberry

45 Shallow dish

A large shallow dish with wide rim, of a whitish-grey finely grained stoneware; the sides of the interior are decorated with ribbing, the centre with moulded lotus flower decoration incorporating the character *kuo* which can be translated as 'office'; covered with a sea-green celadon glaze; the unglazed base burnt a bright orange enclosing a central glazed area.
d. 33·5 cm
Southern Celadon ware
Probably Zhejiang (Chekiang) province
Yuan (Yüan) Dynasty (1260–1368AD)
38.117.25
Bequest of Miss Weightman, 1938
Bought from Bluett & Sons
Note: Plates of this type were frequently covered with a glaze which extended over the base but left an un-glazed band for a setting stand.

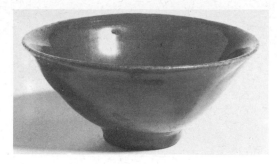

46 Small bowl
A thickly potted conical bowl with slightly out-
turned lip, of dark buff stoneware; covered in a
blue-green celadon glaze, base glazed and footrim
oxidised brown. Similar to Korean Koryo Ware.
d. 9·5 cm at rim, h. 4·3 cm
Later Southern Celadon ware
Probably Zhejiang (Chekiang) province
Yuan (Yüan) Dynasty (1260–1368AD)
38.117.31
Bequest of Miss Weightman, 1938

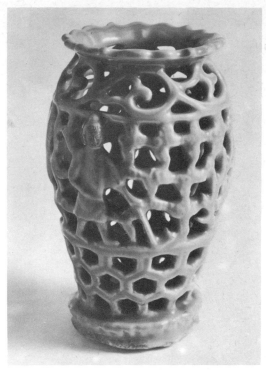

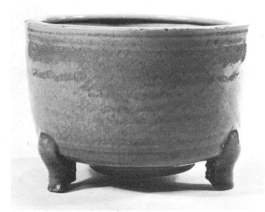

47 Incense burner
A thickly potted incense burner of greyish
porcellanous stoneware, standing on three shaped
legs, the exterior with a carved design of diamond
motifs containing flower heads; covered in a sea-
green celadon glaze, finely crackled; the flattened
protruding base and parts of the underside
unglazed, and the body oxidised orange/brown.
d. 23·2 cm
Southern Celadon ware
Probably Zhejiang (Chekiang) province
Ming Dynasty (1368–1644AD)
38.117.75
Bequest of Miss Weightman, 1938

48 Vase
A vase with a pierced ground, the base slightly
concave; decorated in relief with two standing
figures on the body, each with unglazed faces
turned iron red through the firing; the upper
border composed of scrolls, the lower of cells;
covered in a sage-green celadon glaze, the base
unglazed and burnt an iron red colour.
h. 18·5 cm
Southern Celadon ware
Probably Zhejiang (Chekiang) province
Ming Dynasty (1368–1644AD)
38.117.79
Bequest of Miss Weightman, 1938

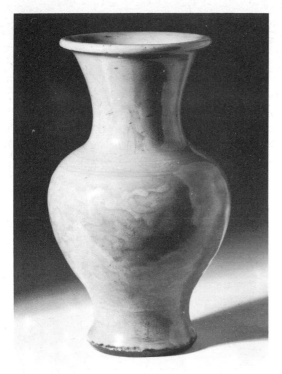 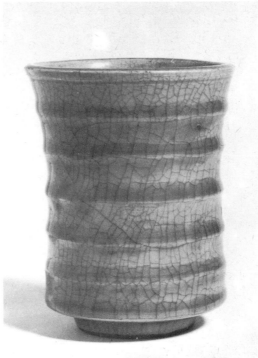

49 Vase
A thickly potted vase of buff/grey stoneware with
wide rim, slightly convex base and splayed foot;
the body with carved decoration of stylised peony
flowers and stiff leaves, and a wave pattern;
covered overall in a pale celadon glaze, the
unglazed footring oxidised dark brown.
h. 20 cm
Southern Celadon ware
Probably Zhejiang (Chekiang) province
Ming Dynasty (1368–1644AD)
38.117.80
Bequest of Miss Weightman, 1938

50 Vase
A thickly potted grey porcellanous stoneware vase,
the rim flared; the body decorated with five
moulded horizontal bands; covered in a thin
translucent sage-green glaze, crackled overall; the
body burnt-red at the foot.
d. 10·5 cm, h. 13·5 cm
Southern Celadon ware
Probably Zhejiang (Chekiang) province
Ming Dynasty (1368–1644AD)
38.117.77
Bequest of Miss Weightman, 1938

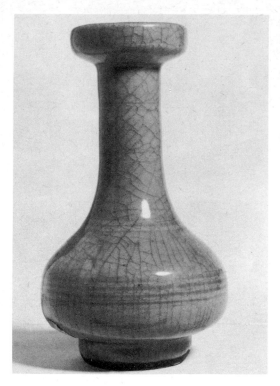

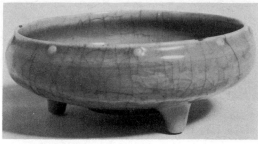

52 Tripod bowl
A shallow tripod bowl of a heavy buff fabric; the exterior with moulded lotus design and a line of studs just below the rim (covered in a thick grey-green glaze heavily crackled); the unglazed centre of the bowl and the unglazed platform base oxidised red in the firing.
d. 16·8 cm, h. 7 cm
Southern Celadon ware
Probably Zhejiang (Chekiang) province
Ming Dynasty (1368–1644AD)
38.117.76
Bequest of Miss Weightman, 1938
Bought from Bluett & Sons

51 Vase
A thickly potted stoneware vase with long neck, flared rim and convex base, of grey stoneware oxidised at the foot, covered overall in a crackled blue-grey celadon glaze.
h. 19·7 cm
Southern Celadon ware
Probably Zhejiang (Chekiang) province
Ming Dynasty (1368–1644AD)
38.117.78
Bequest of Miss Weightman, 1938
Bought from Bluett & Sons

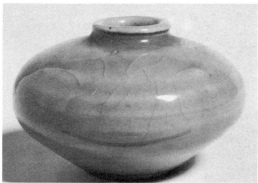

53 Small vase
A squat globular vase of buff coloured stoneware, the rim everted, the base concave and unglazed; covered in a crackled sage-green celadon glaze finishing in uneven line around the sides.
h. 6 cm
Southern Celadon ware
Probably Zhejiang (Chekiang) province
Ming Dynasty (1368–1644AD)
38.117.37
Bequest of Miss Weightman, 1938
Bought from Bluett & Sons

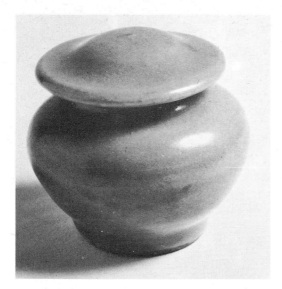 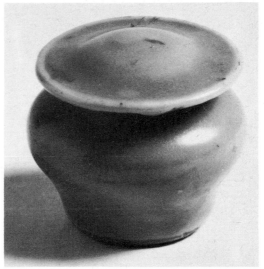

54 A cosmetic box and cover

A cosmetic box and domed cover of grey/white
porcellanous stoneware, the shoulders rounded
and the body tapered; covered in a grey-green
celadon glaze; the base glazed, the foot rim
unglazed and burnt orange.
h. 7 cm incl. lid, d. of lid 6·2 cm
Southern Celadon ware
Probably Zhejiang (Chekiang) province
Ming Dynasty (1368–1644AD)
38.117.33
Bequest of Miss Weightman, 1938
cf Addis (1978) pl.39cc for almost identical piece
from a tomb dated to 1418
Note: This probably formed part of a set
including **55, 56 & 57**.

56 Cosmetic box and cover

A small circular cosmetic box and domed cover, of
whitish porcellanous stoneware, the shoulders
rounded; covered in a grey-green celadon glaze,
the base partly glazed, the shallow footrim
oxidised red where unglazed.
h. 5·5 cm incl. lid, d. of lid 5·8 cm
Southern Celadon ware
Probably Zhejiang (Chekiang) province
Ming Dynasty (1368–1644AD)
38.117.35
Bequest of Miss Weightman, 1938
Bought from Bluett & Sons

55 Cosmetic box and cover

A cosmetic box and domed cover of grey
stoneware; the shoulders rounded, the body
tapered, and the lid with somewhat out-turned
lip; covered in a grey-green celadon glaze, the foot
rim unglazed and burnt orange.
h. 5·7 cm incl. lid, d. of lid 6·1 cm
Southern Celadon ware
Probably Zhejiang (Chekiang) province
Ming Dynasty (1368–1644AD)
38.117.34
Bequest of Miss Weightman, 1938

57 Cosmetic box and cover

A small cosmetic pot and lid of grey-white
porcellanous stoneware, the shoulders rounded
and the body slightly tapered; covered in an
olive-green celadon glaze, the base glazed, the
footrim unglazed and burnt orange.
h. 6 cms, d. of lid 5·5 cm
Southern Celadon ware
Probably Zhejiang (Chekiang) province
Ming Dynasty (1368–1644AD)
38.117.36
Bequest of Miss Weightman, 1938

7 Jun (Chün) ware

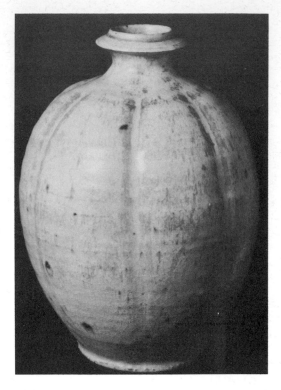

Jun (Chün) ware derives its name from that of one of the districts Junzhou (Chün-Chou), in which it was made. The ware, one of the imperial wares, was produced from the Song (Sung) dynasty on into the Ming dynasty. The ware is related to that known as northern celadon ware, and was made at many kilns in the neighbourhood of Linruxian (Lin-ju-Hsien) and near Yuxian (Yü-hsien) in Henan (Honan) province.

The ash glaze derives its characteristic bluish colour from a combination of the small amount of iron oxide it contains and reduction firing. The innumerable trapped air bubbles in the glaze cause light to be absorbed on the surface. This helps to impart the opacity which is a feature of this ware.

There is a great deal of variation among pieces of Jun (Chün) ware, the finest wares having the bluish colour mentioned above with a smooth, glossy and brilliant surface. A lesser quality, and rather uncommon type of ware, fired slightly lower than stoneware, with a porous body and green glaze (**62**) is thought to be early in date. A later variety, produced from the 12th century to the Ming dynasty, has brilliant purple splashes caused by the addition of copper.

58 Vase
A buff stoneware vase of octafoil section, with rounded shoulders and flattened rim; covered overall with a light turquoise-blue glaze with small brown spots in parts.
d. 5 cm at rim, h. 26 cm
Jun (Chün) type ware
Junzhou (Chün-Chou) region
Henan (Honan) province
13th century or later
Song (Sung) Dynasty (960–1279AD)
1978.361.29
Transferred from the Walker Art Gallery

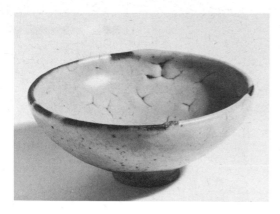 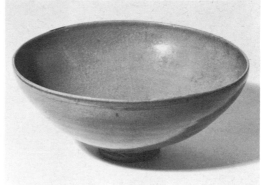

59 Small bowl
A small bowl of light buff stoneware with rounded
sides, the spreading footring bevelled; covered in a
crazed light grey-green glaze stopping short of the
foot in an uneven line, brownish around the rim;
palm eyes on interior and exterior; the base and
footring unglazed.
d. 11 cm, h. 5 cm
Jun (Chün) ware
Junzhou (Chün-Chou) region
Henan (Honan) province
12th–13th century
Song (Sung) Dynasty (960–1279AD)
38.117.13
Bequest of Miss Weightman, 1938

60 Deep bowl
A deep bowl with rounded sides, the body of
greyish stoneware, with spreading bevelled
footring, covered in a deep lavender glaze, burnt
pale brown; the base glazed, the footring
unglazed.
d. 21·8 cm
Jun (Chün) ware
Junzhou (Chün-Chou) region
Henan (Honan) province
11th–13th century
Song (Sung) Dynasty (960–1279AD)
38.117.17
Bequest of Miss Weightman
Bought from Bluett & Sons
cf Hobson (1925–28) Vol.II, pl.21,1

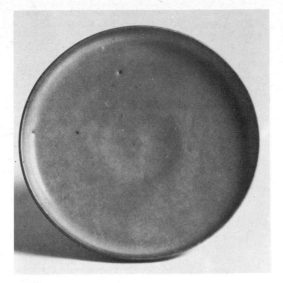 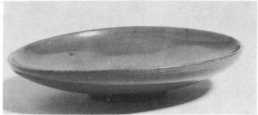

61 Dish

Flat dish with slightly everted rim; foot ring slightly splayed; covered in a light lavender crazed glaze stopping short of the foot in an uneven line, pale brown around the rim; the base glazed; the foot ring unglazed and oxidised reddish brown.

d. 15·5 cm at rim
Jun (Chün) ware
Junzhou (Chün-Chou) region
Henan (Honan) province
13th century
Song (Sung) or Early Yuan (Yüan) Dynasty
(960–1279AD) or (1260–1368AD)
38.117.15
Bequest of Miss Weightman, 1938
Bought from Bluett & Sons
cf Hobson (1925–28) Vol.III, pl.18, C60

62 Flat dish

A small shallow flat dish with convex base of grey porcellanous stoneware, the rim slightly everted; covered with a semi-opaque thin pale olive-green glaze, slightly brownish around the rim, the base glazed; the footring, where unglazed, oxidised dark brown.

d. 15 cm at rim
Green Jun (Chün) ware
Probably from Henan (Honan) province
13th century
Song (Sung) or early Yuan (Yüan) Dynasty
(960–1279AD) or (1260–1368AD)
38.117.19
Bequest of Miss Weightman, 1938
cf Hobson (1925–28) Vol.III pl.18, C60

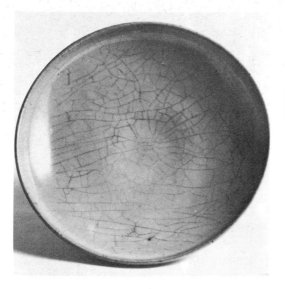

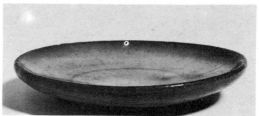

63 Dish

A shallow dish with slightly everted rim, the footring splayed; covered in a light lavender-grey crazed glaze stopping just short of the footring in an uneven line; pale brown around the rim; the footring unglazed and oxidised reddish brown; the base glazed.

d. 19 cm
Jun (Chün) ware
Junzhou (Chün-Chou) region
Henan (Honan) province
13th century
Yuan (Yüan) Dynasty (1260–1368AD)
38.117.16
Bequest of Miss Weightman, 1938
Bought from Bluett & Sons
cf Hobson (1925–28) Vol.III pl.18, C60
 Legeza (1972) Pl.XXIII, Fig.72

64 Flat dish

A flat dish of dark brown stoneware with splayed footring enclosing a recessed base; covered in a bright turquoise glaze stopping short of the footring.

d. 16·5 cm
Jun (Chün) ware
Junzhou (Chün-Chou) region
Henan (Honan) province
13th–14th century
Yuan (Yüan) Dynasty (1260–1368AD)
38.117.18
Bequest of Miss Weightman, 1938

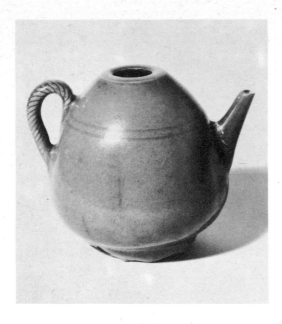

65 Wine pot

A small wine pot of brownish stoneware in the
form of a lotus bud; decorated with two
horizontal lines; the handle plaited; covered in a
crazed lavender-blue glaze, pale brown around the
rim; oxidised coffee-brown on the glazed footring;
the base partly glazed.

h. 9·4 cm

Jun (Chün) ware

Junzhou (Chün-Chou) region

Henan (Honan) province

Yuan (Yüan) Dynasty (1260–1368AD)

56.39.14

Bought from R. C. Terry, 1956

8 Black/brown wares from Henan province, Jizchou ware and Jian ware

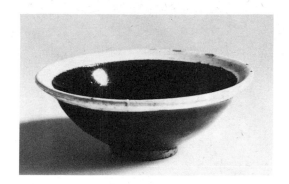

According to legend Japanese monks, after a visit to a Buddhist monastery in China, took back home with them the black pottery bowls they had used during their stay. The Japanese group all these black wares together under the name Temmoku, the Japanese reading of a Chinese word they originally applied only to Jian (Chien) ware. The northern black/brown wares from Henan (Honan) province are more common than the finer wares of Fujian (Fukien). They were manufactured at the same sites as the Cizhou (Tz'ù-chou) wares. **66** is a good example of the products of these kilns.

Jizhou (Chi-Chou) wares take their name from the market centre where the products of a number of kilns were sold. A number of interesting and ingenious techniques were used by the potters, one of the best known being the leaf decorated bowls. The decoration of these was achieved by glueing a leaf on to the unfired body of the bowl and covering it with a glaze containing iron oxide. During the oxidising firing the leaf burnt out leaving a light brown stain in its place (**70**), surrounded by a dark brown or black glaze. Another well known variety was decorated in a similar way with black paper cutouts (**69**). By applying a yellowish glaze over the black and firing in a reducing atmosphere, the decoration remains dark against a flecked glaze.

The Jian (Chien) wares were especially admired by the Japanese. The wares were used only to make bowls with a dark, coarse stoneware body covered with a black glaze streaked with brown or blue-black and known as 'hare's fur' glaze (**72**, **73** and **74**).

a) Black-brown wares from Henan province

66 Bowl

A small bowl of grey-white stoneware with everted rim and slightly rounded sides; the body covered in a lustrous black glaze, the rim in a creamy white clear glaze over a white slip; the small shallow footring and base unglazed.
d. 11·7 cm, h. 4·2 cm
Northern black-brown glazed ware
Henan (Honan) province
11th–13th century
Song (Sung) Dynasty (960–1279AD)
38.117.51
Bequest of Miss Weightman, 1938
Bought from Bluett & Sons
cf Ayers (1968) pl.A, 62
 Beurdeley (1974) p.146

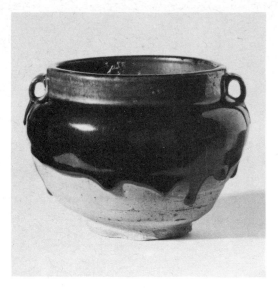
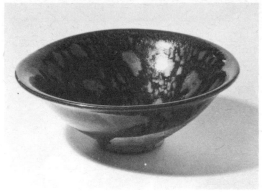

67 Jar

A small jar of buff stoneware, with two vertical
loop handles attached to the shoulder and short
neck, the footring broad and splayed with patches
of kiln grit adhering in places; covered in a thick
lustrous dark blue streaked glaze, brown at the
mouth, finishing in an uneven roll forming
droplets half way down the sides; the interior
glazed, with radial marks and adhering kiln grit.
d. 14 cm, h. 11 cm
Northern black-brown glazed ware
Henan (Honan) province
11th–13th century
Song (Sung) Dynasty (960–1279AD)
38.117.52
Bequest of Miss Weightman, 1938
cf Legeza (1972) pl.XXV, 75
 Wen-Wu (1964) No.8, fig.14

68 Tea bowl

A tea bowl of buff stoneware, finely potted, with
slightly rounded sides, everted rim and shallow
recessed base; covered in a lustrous blue-black
glaze with 'rust marks' and speckles around the
mouth, the glaze stopping short of the short
square cut foot in an uneven line. A lump of kiln
grit is attached to the foot.
d. 12·5cm
Northern black-brown glazed ware
Probably from Henan (Honan) province
North China
11th–13th century
Song (Sung) Dynasty (960–1279AD)
38.117.53
Bequest of Miss Weightman, 1938
Bought from Bluett & Sons

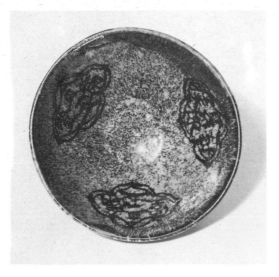 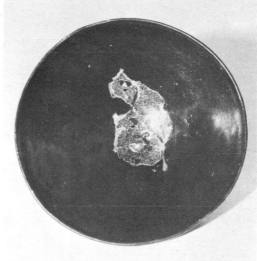

b) Jizhou ware

69 Tea bowl

A buff-grey stoneware tea bowl of conical form;
the inside decorated with three paper cut
medallions containing good augory inscriptions.
The first inscription contains the characters Jin,
Man, You and Tang which can be translated as
Gold, Jade, full, parlour; the second reads 'to be
given an office by the Emperor and hence wealth
will be forthcoming'. The third inscription is
indecipherable. The bowl is covered in a lustrous
black glaze with inside a mottled effect and
outside spots of buff colour. There is a painted
mark on the base which reads 'No. 7 piece of
green/blue/shop'. The bowl is restored around the
lip.
d. 11·5 cm, h. 6 cm
Jizhou (Chi-Chou) ware
Yonghe (Yung-Ho) near Jizhou (Chi-Chou)
Jiangxi (Kiangsi) province
12th–13th century
Song (Sung) Dynasty (960–1279 AD)
38.117.58
Bequest of Miss Weightman, 1938
Bought from Bluett & Sons
cf Ayers (1968) pp.74–75
 Medley (1976) pp.158–59

70 Tea bowl

A buff-grey coloured stoneware tea bowl, the
interior with leaf decoration (leaf Temmoku); the
foot-rim knife pared; covered in a dark brown
glaze, falling short of the base; the base unglazed.
d. 14·7 cm
Jizhou (Chi-Chou) ware
Yonghe (Yung-Ho) near Jizhou (Chi-Chou)
Jiangxi (Kiangsi) province
13th century
Song (Sung) Dynasty (960–1279 AD)
38.117.57
Bequest of Miss Weightman, 1938
Bought from Bluett & Sons
cf Tokyo National Museum (1953) pl.105

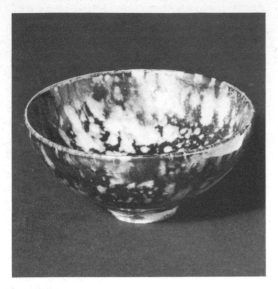
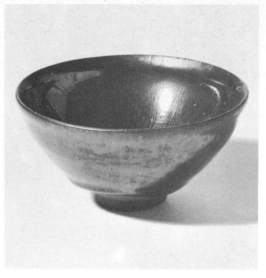

71 Tea bowl
A tea bowl of buff stoneware with rounded sides;
covered overall with a 'Tortoiseshell glaze' of dark
brown and beige stopping short of the footring;
the base unglazed.
d. 12·2 cm
Jizhou (Chi-Chou) ware
Yonghe (Yung-ho) near Jizhou (Chi-Chou)
Jiangxi (Kiangsi) province
Song (Sung) Dynasty (960–1279AD)
38.117.54
Bequest of Miss Weightman, 1938
Bought from Bluett & Sons
cf Beurdeley (1974) p.138
 Valenstein (1975) pp.100–102
Note: The 'Tortoiseshell' effect was achieved by
mixing a very delicate slip with the glaze to make
it more opaque.

c) Jian ware

72 Tea bowl
A tea bowl of conical form with a slightly flared
rim; the body of coarse brown stoneware; covered
in heavy lustrous glaze, streaked with fine blue
'hare's fur' markings inside, the glaze stopping
short of the foot in a thick roll.
d. 11·5 cm, h. 6 cm
Jian (Chien) ware
near Jianning (Chien-ning)
Fujian (Fukien) province
Song (Sung) Dynasty (960–1279AD)
38.117.56
Bequest of Miss Weightman, 1938
Bought from Bluett & Sons
cf Ayers (1968) vol.1, pl.A64

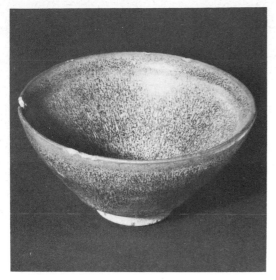
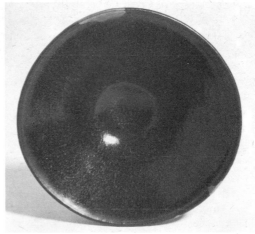

73 Tea bowl
A thickly potted tea bowl of conical form, the
body of dark brown, coarse stoneware, the sides
slightly rounded; covered in a black glaze with
light brown and cream 'hare's fur' markings,
ending in an uneven line above the unglazed foot;
the base unglazed. The tea bowl is damaged
around the rim.
d. 12·5 cm
Jian (Chien) ware
Near Jianning (Chien-ning)
Fujian (Fukien) province
Song (Sung) Dynasty (960–1279AD)
38.117.14
Bequest of Miss Weightman, 1938

74 Tea bowl
A tea bowl of conical form, the body of coarse
brown stoneware with a heavy lustrous 'hare's fur'
glaze of brown and black, the glaze running down
the outside wall in droplets. The rim has two gold
repairs.
d. 12 cm
Jian (Chien) ware
Near Jianning (Chien-ning)
Fujian (Fukien) province
Song (Sung) Dynasty (960–1279AD)
38.117.55
Bequest of Miss Weightman, 1938
Bought from Bluett & Sons

9 Cizhou (Tz'û-chou) type wares

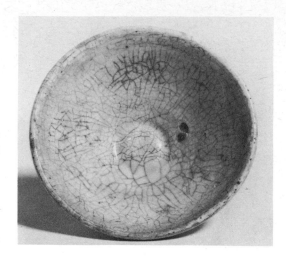

The Cizhou (Tz'û-chou) district in the south of Hebei (Hopei) province, near to the borders of Henan (Honan) province, has given its name to this group of stonewares which differ considerably from each other. They were produced at a number of kilns in northern China. The kilns producing Cizhou (Tz'û-chou) type wares often made as well other high quality wares such as Jun (Chün) ware. This has been shown by recent finds at Baguading (Pa-kua-tung).

The stoneware body varies considerably in colour, brown, grey, buff or buff-white, and is usually covered with a white slip under a transparent glaze. A variety of techniques were used to decorate the wares, including incising, carving, 'sgraffiato' and painting.

The finest example of Cizhou (Tz'û-chou) wares in the museum is a flattened oval pillow (**78**) with painted decoration in dark brown of the Southern Song (Sung) academy style. The pillow is very similar to the pillow at Berlin thought to be unique (Staatliche Museen 1970, no.62) and is of major importance.

75 Small bowl
A shallow bowl with slightly flared rim; the inside covered in a cream-white slip under a transparent crackled glaze extending over the rim and stopping short of the foot in an uneven line.
d. 10·5 cm, h. 3·5 cm
Cizhou (Tzû-chou) type ware
Hebei (Hopei) province
11th–13th century
Song (Sung) Dynasty (960–1279AD)
38.117.60
Bequest of Miss Weightman, 1938
Bought from Bluett & Sons

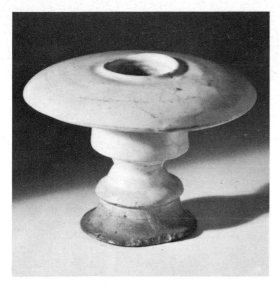 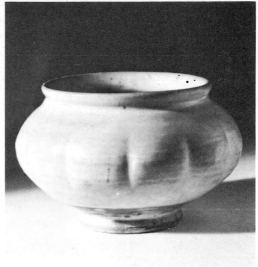

76 Candlestick
A squat candlestick with wide rim; covered in a
white slip under a transparent crackled glaze, the
flared hollow foot unglazed.
h. 9·5 cm, d. 13 cm
Cizhou (Tzû-chou) type ware
Hebei (Hopei) province
11th–13th century
Song (Sung) Dynasty (960–1279AD)
38.117.70
Bequest of Miss Weightman, 1938
Bought from Bluett & Sons

77 Vase
A vase with segmented body, the wide mouth
somewhat flared; covered overall in a creamy
white slip, except for a band immediately above
the footring, the outside, except for the footring
and base, covered in a transparent glaze extending
over the lip and ending inside in an uneven line
below the rim.
h. 8·5 cm, d. 13·5 cm
Cizhou (Tz'û-chou) type ware
Hebei (Hopei) province
11th–13th century
Song (Sung) Dynasty (960–1279AD)
38.117.67
Bequest of Miss Weightman, 1938
Note: A very similar vase was exhibited at the
British Museum in the autumn of 1979 on loan
from the Collection of the late Count Antoene
Seilern. Exhibit No. Se.81

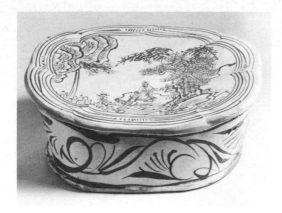

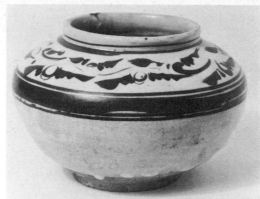

78 Pillow

A flattened oval pillow, the base bevelled round
the edge and impressed with a rectangular stamp
bearing the seal Zhang (Chang) Jia (Chia) Zao
(Tsao) ('Chang family made'); a circular air vent
positioned centrally in the back; the top and
sides covered in a white slip; the top painted in
rust brown with a seated figure in contemplative
attitude, to his right a pine tree, to his left an
overhanging cliff with a waterfall tumbling down
into a lake in front of the figure, the scene
enclosed within a stylised tendril border of five
bands interspersed with vertical dashes; the sides
painted with a stylised running scroll pattern; a
transparent glaze over the top and sides, the base
unglazed.

h. 12 cm
top 27 × 22 cm
Cizhou (Tz'û-chou) type ware
Hebei (Hopei) province
Jin (Chin) Dynasty (1115–1234AD)
56.39.18
Bought from R. C. Terry, 1956
cf Medley (1975) pl.1
 Staatliche Museen (1970), no. 62
Note: Slight changes in the tendril border and
classic scroll border from examples dated by
Wirgin as 11–12th century (Wirgin 1979,
pp.86–117) make it probable that this example is
slightly later in date.

79 Jar

A thickly potted jar of buff-grey stoneware with
rounded shoulders and slightly out-turned rim;
covered in a creamy-white slip stopping short of
the footring; painted in dark brown around the
shoulder with a continuous band of simplified
leaf scrolls; the outside covered with a thick
transparent crazed glaze; the base and broad
footring unglazed; the interior covered with a
mottled green-brown glaze.

h. 9 cm, d. 13·5 cm
Cizhou (Tz'û-chou) ware
Hebei (Hopei) province
Ming Dynasty (1368–1644AD)
38.117.74
Bequest of Miss Weightman, 1938

10 Ding (Ting) porcelain and similar wares

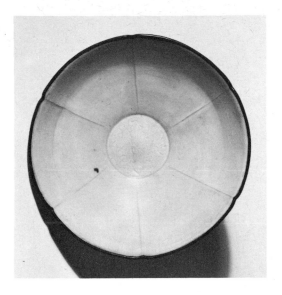

The name of this ware is derived from Dingzhou (Ting-chou) in Hebei (Hopei) province where it was first produced. It was an imperial ware made from the second half of the tenth century through to the Yuan (Yüan) dynasty and later.

Its characteristics are a thin white porcelain body with a transparent ivory toned glaze. The pieces were often fired upside down on the rim (**80**) rather than on the foot, perhaps to spread the weight of the pot over a wider area thus reducing the possibility of warping during firing.

Decoration on the porcelain consisted of incised motifs, usually floral designs, (**80**, **82**, **84**) and moulded designs (**83**, **85** and **86**).

The discovery in 1941 of the kilns where the porcelain was produced has made it possible to identify and distinguish the different groups of wares. The kilns were situated at Jiancicun (Chien-tzû Ts'un) and Yenshancun (Yen-shan-ts'un). Varieties of the ware, all of which are scarce, are known as Red Ding (Ting) (**81**), Black Ding (Ting) and Purple Ding (Ting).

A beautiful bowl (**80**) is one of the finest examples of Chinese porcelain in the collection.

80 Bowl
Shallow bowl with wide mouth and slightly curved sides; the inside divided into six compartments by moulded lines pressed from the outside of the bowl; the centre freely carved with a lotus flower and leaves; covered in a transparent glaze, the rim unglazed and bound with copper.
h. 7·5 cm, d. 21 cm
Ding (Ting) porcelain
Dingzhou (Ting-chou) region
Hebei (Hopei) province
11th–12th century
Song (Sung) Dynasty (960–1279AD)
38.117.66
Bequest of Miss Weightman, 1938
Bought from Bluett & Sons

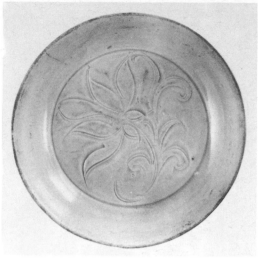

81 Shallow dish

A finely potted shallow dish, the base unglazed
and buff in colour, with wide mouth and slightly
curved sides of grey-white porcelain covered in a
metallic-like rusty brown glaze, darker round the
rim, the base unglazed and buff in colour.

h. 1·8 cm, d. 10·7 cm

Red Ding (Ting) porcelain type

Dingzhou (Ting-chou) region

Hebei (Hopei) province

11th–12th century

Song (Sung) Dynasty (960–1279AD)

38.117.50

Bequest of Miss Weightman, 1938

Bought from Bluett & Sons

82 Saucer

A small saucer of grey-white, slightly translucent,
porcellanous ware with slightly rounded sides,
the inside carved with a lotus flower, the underside
with a crisply cut recessed base showing radial
marks; covered with a grey-white glaze, sepia in
colour where thicker; unglazed at the rim.

h. 2·2 cm, d. 12·3 cm at rim

Ding (Ting) porcellanous ware

Dingzhou (Ting-chou) area

Hebei (Hopei) province

12th–13th century

Song (Sung) Dynasty (960–1279AD)

38.117.63

Bequest of Miss Weightman, 1938

Bought from Bluett & Sons

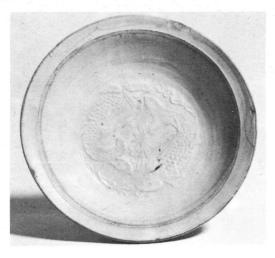
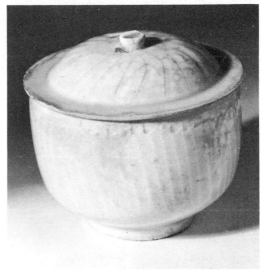

83 Bowl

A somewhat thickly potted bowl of buff-white porcellanous ware, with a ledge rim and sharply cut foot; the interior moulded with two carp amongst water weeds symbolising conjugal felicity; covered in a grey-ivory coloured glaze; the underside partly glazed, the foot and base unglazed.

h. 3·5 cm, d. 12·4 cm at rim
Ding (Ting) porcellanous ware
Dingzhou (Ting-chou) region
Hebei (Hopei) province
12th–13th century
Yuan (Yüan) Dynasty (1260–1368)
38.117.64
Bequest of Miss Weightman, 1938

84 Bowl and cover

A deep bowl with slightly tapering sides and a domed cover with ledge rim and button finial, of whitish fine grained porcellanous ware; the bowl carved with curving vertical lines edged at the rim by a band of chevrons; the lid carved with a wheel design; covered overall in grey-white glaze, darker where thicker; the underside of the rim of the lid, the footring of the bowl, the base of the interior of the bowl and lid, unglazed and oxidised pink-brown. There are wheel marks on the interior of the cup, and the footring is finely cut.

h. 6 cm, d. 8 cm
Ding (Ting) porcellanous ware
Dingzhou (Ting-chou) region
Hebei (Hopei) province
12th–13th century
Jin (Chin) Dynasty (1115–1234)
38.117.69
Bequest of Miss Weightman, 1938
Bought from Bluett & Sons
Note: A very similar Ding (Ting) bowl and cover was exhibited at the British Museum in the autumn of 1979 exhibit No. Se.53

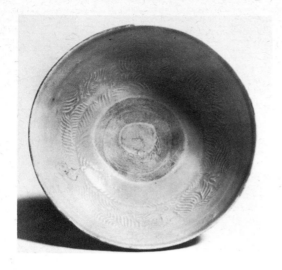

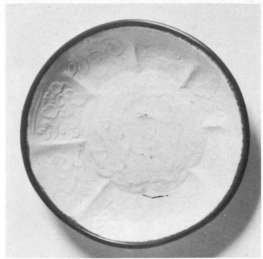

85 Bowl

A finely potted bowl with slightly rounded sides
and a small foot; the interior decorated with a
band of moulded designs of pond weeds and
storks amidst waves, and including two
unidentifiable characters; covered in an ivory
glaze, grey-green where thick; fired on a ring
leaving a circular unglazed band on the base of
the interior of the bowl; the base unglazed.
h. 4 cm, d. 10·8 cm
Ding (Ting) type porcelain
Dingzhou (Ting-chou) region
Hepei (Hopei) province
Yuan (Yüan) Dynasty (1260–1368)
38.117.65
Bequest of Miss Weightman, 1938
Bought from Bluett & Sons

86 Small shallow dish

A porcellanous stoneware dish with rounded
sides, and flat base; fired upside down on its rim,
the interior with eight ribs, forming eight panels
each containing floral designs; the centre moulded
with a lion-dog with chain collar; covered in an
ivory toned glaze. The rim is bound with copper.
d. 9·3 cm
Ding (Ting) porcellanous ware
Dingzhou (Ting-chou) region
Hebei (Hopei) province
13th–14th century
Yuan (Yüan) Dynasty (1260–1368)
38.117.61
Bequest of Miss Weightman, 1938
Bought from Bluett & Sons

11 Qingbai (Ch'ing-pai) porcelain and related wares

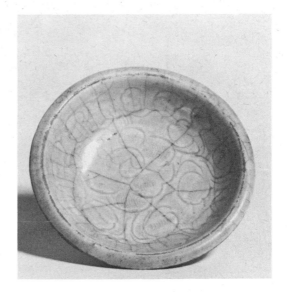

This name is recorded in Chinese literature as early as the Southern Song (Sung) dynasty, 1128 to 1279AD, although until recent times the ware was known to dealers by the misnomer Yingqing (Ying-Ch'ing) meaning shadowy blue or green. The ware was produced over a very wide area of southern China stretching from Jiangxi (Kiangsi) to Fujian (Fukien), the finest quality examples coming from Xianghu (Hsiang-hu), Hutian (Hu-t'ien) and Jizhou (Chi-chou). Its main characteristic is its very fine white porcelain body covered by a glaze varying from brilliant bluish-green to a pale blue-grey colour. This glaze colour is famous, the Chinese themselves calling the imperial ware *Qingbai*. As the Chinese character for the colour blue is also that for green, this may be translated as bluish white or greenish white.

Decoration was either incised (**87**, **89**, **91**, **94**) or moulded (**92**). Dishes were often fired on their rims and then bound with copper, much like Ding (Ting) wares.

A great many pieces from south China were exported to south east Asia, the near East and the Philippines, where in recent years large scale excavations have been carried out.

87 Shallow bowl
A finely potted small bowl with rounded ledge rim, on a high foot; the centre carved with peony motif; covered in a greyish crackled-blue glaze; the base unglazed and oxidised a light brown.
h. 3 cm, d. 8·25 cm
Qingbai (Ch'ing-pai) porcelain
Jingdezhen (Ching-tê Chên) region
Jiangxi (Kiangsi) province
11th–12th century
Song (Sung) Dynasty (960–1279AD)
38.117.6
Bequest of Miss Weightman, 1938
Bought from Bluett & Sons

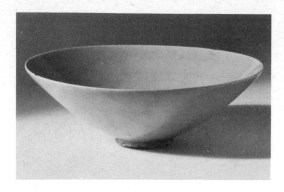 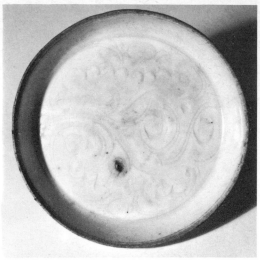

88 Bowl
A grey-white translucent porcelain bowl of conical shape; covered in a pale bluish-green glaze; the unglazed footring with adhering kiln grit; the rim chipped.
d. 15 cm
Perhaps Qingbai (Ch'ing-pai) porcelain
Jingdezhen (Ching-tê Chên) region
Jiangxi (Kiangsi) province
11–12th century
Song (Sung) Dynasty (960–1279AD)
38.117.27
Bequest of Miss Weightman, 1938

89 Shallow dish
A finely potted translucent porcelain saucer-dish with sloping walls and slightly concave base; the centre freely carved with designs of lotus flowers and foliage; covered overall in a pale bluish glaze; the mouth rim unglazed and burnt light brown.
h. 1·5 cm, d. 10 cm at rim
Qingbai (Ch'ing-pai) porcelain
Jingdezhen (Ching-tê Chên) region
Jiangxi (Kiangsi) province
11th–12th century
Song (Sung) Dynasty (960–1279AD)
38.117.10
Bequest of Miss Weightman, 1938
Bought from Bluett & Sons

90 Small shallow dish
A finely potted hexafoil dish of shallow conical
shape, the base slightly concave; the interior
decorated with six pressed ribs; covered in a
bluish-white glaze; the base unglazed and burnt a
light brown.
h. 2·4 cm, d. 10·8 cm
Qingbai (Ch'ing-pai) porcelain
Jingdezhen (Ching-tê Chên) region
Jiangxi (Kiangsi) province
12th–13th century
Song (Sung) Dynasty (960–1279AD)
38.117.8
Bequest of Miss Weightman, 1938
Bought from Bluett & Sons
cf Legeza (1972) pl.LVIII, 169

91 Bowl on high foot
A finely potted and highly translucent porcelain
bowl with five-lobed rim and rounded sides;
decorated in the centre with an incised peony on a
hatched ground; covered in a pale blue glaze;
lumps of kiln grit adhering to the unglazed base
and footring, oxidised brown in the firing. The
rim is chipped.
h. 3·8 cm, d. 10·5 cm
Qingbai (Ch'ing-pai) porcelain
Jingdezhen (Ching-tê Chên) region
Jiangxi (Kiangsi) province
11th–12th century
Song (Sung) Dynasty (960–1279AD)
38.117.9
Bequest of Miss Weightman, 1938
Bought from Bluett & Sons
cf Beurdeley (1974) p.141 & fig.87

92 Shallow dish
A shallow dish of light grey fabric with moulded decoration of lotus and fish; covered in a light pearly grey crazed glaze except on rim.
d. 14·3 cm, h. 2·5 cm
Qingbai (Ch'ing pai) porcelain
Jingdezhen (Ching-tê Chên) region
Jiangxi (Kiangsi) province
13th century
Yuan (Yüan) Dynasty (1260–1368)
38.117.5
Bequest of Miss Weightman, 1938

93 Small dish
A small dish of grey-white porcelain, extremely finely potted, with low round sides and recessed footring; divided into six segments by moulded ribs; covered overall in a faint blue-grey glaze, and fired upside down on the unglazed rim.
h. 1·7 cm, d. 11·5 cm
Qingbai (Ch'ing-pai) porcelain
Jingdezhen (Ching-tê Chên) region
Jiangxi (Kiangsi) province
12th–13th century
Song (Sung) Dynasty (960–1279AD)
38.117.62
Bequest of Miss Weightman, 1938
Bought from Bluett & Sons

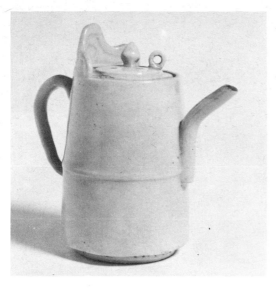

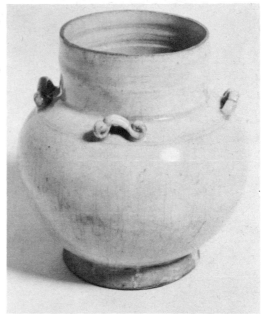

94 Wine pot

A white porcelain thickly potted pot of slightly
tapering cylindrical shape with a roughly cut
footring; decorated outside with a moulded rib;
the neck above the plain pipe handle decorated
with a small ledge of cloud form with incised
decoration; the lid with a ring attachment and a
finial, and decorated with four greyish blue spots.
The pot is covered inside and out with a crazed
pale blue glaze which extends down to the foot;
the body, where unglazed, oxidised light orange
in the firing and showing an orange translucency
through transmitted light.

h. 11 cm, d. 6·5 cm
Qingbai (Ch'ing-pai) porcelain
Jingdezhen (Ching-tê Chên) region
Jiangxi (Kiangsi) province
13th–14th century
Yuan (Yüan) Dynasty (1260–1368)
38.117.11
Bequest of Miss Weightman, 1938

95 Vase

A somewhat thickly potted vase of bulbous form
with a cylindrical neck with a buff porcellanous
body; decorated on the shoulder with four loop
handles in the form of cloud scrolls and just
below the neck with two concentric incised lines;
covered in a pale bluish glaze crazed overall with
patches of buff colour; the rim unglazed; the
base and footring unglazed and showing wheel
marks.

h. 12·5 cm, d. 7·7 cm
Qingbai (Ch'ing-pai) type porcellanous ware
Possibly Yonghu (Yung-ho) region
Jiangxi (Kiangsi) province
12th–13th century
Song (Sung) Dynasty (960–1279AD)
38.117.12
Bequest of Miss Weightman, 1938
Bought from Bluett & Sons

12 Shufu (Shu-fu) porcelain

The name of this ware derives from the fact that pieces very often, although not always, bear the two characters *shu* and *fu* meaning 'imperial palace' or, more generally, 'privy council'. Shufu porcelain was an imperial ware produced during the Yuan (Yüan) dynasty and later, similar to Qingbai (Ch'ing-pai) porcelain, but more heavily potted and with a slightly opaque glaze, the white porcelain body oxidising to an orange colour where unglazed, and the base nearly always convex.

Both incised and moulded decoration were used, and moulded festoons were a fairly common motif. The porcelain is thought to have been produced near Jingdezhen (Ching-tê Chên) in Jiangxi (Kiangsi) province.

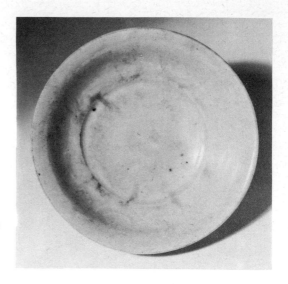

96 Bowl

A thickly potted bowl, the sides somewhat rounded, spreading slightly at the lip, the base slightly concave; decorated in low relief with moulded designs of pendants on the inside; covered in a bluish tinged glaze flawed with pin holes; the footring and base unglazed and burnt slightly orange in parts.
h. 10·75 cm
Shufu (Shu-Fu) type porcelain
Jingdezhen (Ching-tê Chên) region
Jiangxi (Kiangsi) province
Yuan (Yüan) Dynasty (1260–1368) or later
38.117.7
Bequest of Miss Weightman, 1938

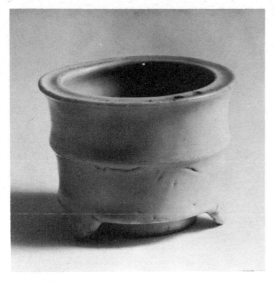 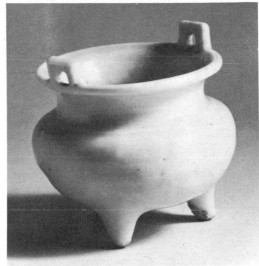

97 Incense burner
Cylindrical incense burner of whitish fine-grained stoneware with flared lip decorated with a central rib; resting on three small cloud form feet; the interior covered with whitish-green celadon glaze, the footrim burnt slightly orange.
h. 6 cm
Shufu (Shu-fu) type porcelain
Jingdezhen (Ching-tê Chên) region
Jiangxi (Kiangsi) province
Yuan (Yüan) Dynasty (1260–1368) or later
38.117.71
Bequest of Miss Weightman, 1938
Bought from Bluett & Sons
cf Legeza (1972) pl.102

98 Incense burner
A thickly potted light grey porcellanous stoneware vessel in the form of a *ding* upon three legs, with a slightly upturned rim, having two square cut handles flanking the rim; covered with a very pale grey-green celadon glaze. Particles of sand adhere to the tripod legs.
h. 7·25 cm
Shufu (Shu-fu) type porcelain
Jingdezhen (Ching-tê Chên) region
Jiangxi (Kiangsi) province
Yuan (Yüan) Dynasty (1260–1368) or later
38.117.72
Bequest of Miss Weightman, 1938
Note: Archaic bronze forms, such as this example, were favoured amongst the scholar class of China.

13 Marbled wares

This variety of ware was produced by kneading together clays of various colours, usually brown and white. It was during the Tang dynasty that the ware emerged, continuing in production over a long period until the early Ming dynasty.

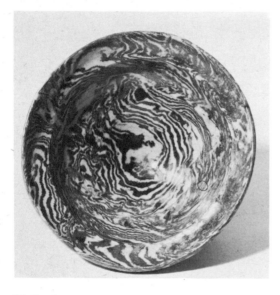

99 Bowl
A small bowl with everted lip of marbled ware; covered in a thin clear glaze; the base glazed and the footrim unglazed.
d. 13·5 cm
Marbled ware
North China
Yuan (Yüan) Dynasty (1260–1368) or later
38.117.59
Bequest of Miss Weightman, 1938

14 Ming and Qing (Ch'ing) Dynasty wares

14a) Underglaze blue decorated porcelain
This group of wares was produced from the Ming dynasty to the close of the Qing (Ch'ing) dynasty. The only example in the collection of the Ming dynasty (**100**) is of a fairly common type, made for export to the West. The area of manufacture was centred upon Jingdezhen (Ching-tê Chên).

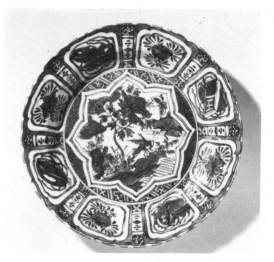

100 Flat dish
A thinly potted porcelain dish, with moulded compartments to the rim; painted in underglaze light blue, the well decorated with tree peony, rocks and insects; the base glazed with radial marks and pin holes, the footrim unglazed and with kiln grit adhering.
d. 32 cm
Underglaze blue decorated porcelain
KRAAK PORSELEIN
South China
Wanli (Wan-li) period (1573–1619)
Ming Dynasty
1973.126.3912
Transferred from the Walker Art Gallery, 1973
Given by Miss Cotton 1946
Note: The name KRAAK PORSELEIN is derived from the Dutch name for the Portuguese ship *Carrack* which was captured in 1603 with a cargo of this ware.

101 Large plate

A porcelain plate with dished well and ledge rim; painted in underglaze blue with chrysanthemum and peony heads; covered in a faint blue translucent glaze; the rim and footrim unglazed and burnt light orange in the firing; the base painted in underglaze blue with a leaf within a double circle, and glazed.

d. 42 cm
Underglaze blue decorated porcelain
Jingdezhen (Ching-tê Chên) region
Jiangxi (Kiangsi) province
Early 17th century
Transitional period
M2007
Given by Joseph Mayer, 1867

102 Jar

A porcelain jar painted in underglaze blue with figures in a garden; the interior covered in a transparent glaze and with radial marks; the rim unglazed and stained brown; the base painted in underglaze blue with a double ring and glazed; the footrim unglazed. The base is cracked.

h. 19·5 cm
Underglaze blue decorated porcelain
Jingdezhen (Ching-tê Chên) region
Jiangxi (Kiangsi) province
Kangxi (K'ang-hsi) period (1662–1722)
Qing (Ch'ing) Dynasty
63.1.130
Bequest of Mrs Stannard, 1963
Note: Jars decorated with prunus blossom, on cracked ice, similar in form to this type were used to contain New Year gifts.

103 Jar

A porcelain jar painted in underglaze blue with figures including an attendant on a *kylin*; the interior covered in a transparent glaze and with radial marks; the rim unglazed and stained dark brown; the base painted in underglaze blue with a double ring and glazed, the footring unglazed.

h. 23 cm
Underglaze blue decorated porcelain
Jingdezhen (Ching-tê Chên) region
Jiangxi (Kiangsi) province
Kangxi (K'ang-hsi) period (1662–1722)
Qing (Ch'ing) Dynasty
63.1.131
Bequest of Mrs Stannard, 1963

104 Bowl

A porcelain bowl with rounded sides; the interior painted in underglaze blue with four peony flowers sprouting from the ground, with a trellis border; the exterior of the bowl with a cafe-au-lait glaze; covered overall in a clear glaze; the base glazed and footrim unglazed; with barnacles adhering to the walls.

d. 15 cm
Underglaze blue decorated porcelain
Jingdezhen (Ching-tê Chên) region
Jiangxi (Kiangsi) province
Qianlong (Ch'ien-lung) period (1736–1795)
Qing (Ch'ing) Dynasty
9.9.90.2
Bought from Mr Gibson, 1890
Found in the wreck of the Göteberg
Note: The barque *Göteberg* sank in 1745, carrying a large cargo including porcelain, silk and tea. The translation of articles in the Swedish newspaper Göteborgs-Posten, Gothenburg, dated 7 June and 5 August, 1875 is taken from the Museums records. 'In the year 1745 (i.e. 130 years ago) the barque *Göteberg* was wrecked on the ground which is now called Göteborgsgrundet. She belonged to the East India Company of this town, and came from China, laden with Silk, Tin, Tea, China, and other articles, of which further mention is made in the ship's log, kept in the Museum at Gothenburg. The general opinion was that the wreck contained treasures which were supposed to be inaccessible. About ten years ago a diver, Mr Bourn, tried to save the cargo. He could only bring up a small quantity of china, probably because he had to blast the wreck in order to get near the tin, which necessarily caused the destruction of a great portion of the china. In the meantime, part of the tin was secured, but the whole was not sufficient to pay the large expenses connected with this undertaking, which, therefore, was abandoned. Another Diving Company has now, under the management of Captain M. Lampa, resumed the work, and its success almost surpasses all expectations. The work is carried on with great spirit and carefulness. During the first weeks the divers could only find broken parts of several articles, and were not able to meet with anything in good condition. The top deck of the ship was entirely off, and the second deck had fallen down, causing a great breakage of

china. The divers had to dig 7 or 8 ft through the clay to enable them to reach the remaining part of the cargo, which at last was discovered. The work was rendered very difficult through the china splinters, which cut the divers' hands, although they were furnished with suitable gloves. At last they succeeded in bringing to the surface about 200 dozen unbroken china articles of different kinds and qualities, such as plates, tea and coffee cups, punch bowls etc. There is a small quantity of plates which seem to have been intended for the royal family, as they are embellished with the monogram of Frederick I. A great number of the coffee cups are particularly fine and elegant as to shape; almost equal to glass in transparency. They have no doubt intended to smuggle in the principal part of the china, as the divers have found some hundred dozen china articles stowed away in the keel. The origin of an old tradition in the neighbourhood, to the effect the *Göteberg* was run aground, might thus be explained. Captain Lampa believes that the principal part of the cargo was saved soon after the wreck, as what he and divers found consisted mostly of ballast, with the exception of the china. It is supposed that all the cargo has now been recovered, and the divers are at present employed in bringing up parts of the hulk. There are a lot of oak planks which have not been at all damaged by the action of the water, and which are quite covered with china splinters. The Diving Company have had them carried to Gamla-Warfoet, to be inspected by carpenters and others. As this oak would be exceedingly suitable for manufacturing into furniture, there is no doubt it would prove of great interest and attractive to connoisseurs.'

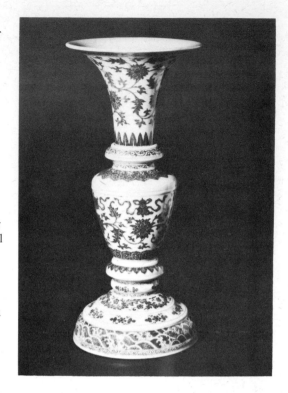

105 Vase
A porcelain vase with glazed mouth, and with balaster body; painted in underglaze blue with peony amidst buddhist symbols, the lower border of stylized wave pattern; covered overall with a transparent glaze; the broad footrim unglazed and oxidised red-brown, the base glazed.
h. 39 cm
Underglaze blue decorated porcelain
Jingdezhen (Ching-tê Chên) region
Jiangxi (Kiangsi) province
Qianlong (Ch'ien-lung) period (1736–1795)
Qing (Ch'ing) Dynasty
50.31.68
Lent by Lt Col Bell, 1950
Collected by Sir Charles Bell in Tibet c. 1920

14b) Famille verte wares

The term *famille verte* was devised by A. Jacquemart, a Frenchman, in the 19th century and should only be applied to those green enamelled wares made during the 17th century and later. The designs found on *famille verte* are broadly the same as those found on contemporary blue and white. They comprise landscapes with fantastic rocks, trees, flowering plants, animals and dragons, the phoenix and other birds, fishes, children and all kinds of everyday objects and auspicious emblems. The designs were largely taken from books with illustrations after famous artists.

It is difficult to establish the chronology of the *famille verte* of the Kangxi (K'ang-hsi) period. Generally, the stronger the line of the object and the bolder the colours and the painting, the earlier it is. The later wares tended towards an egg shell like fabric and were often slender and over-elegant in shape, the forerunners of the later porcelain wares such as *famille rose*. Fine quality is rare in the *famille verte* made for export to the uncritical markets of Europe.

Famille verte decoration had almost ceased by the reign of Qianlong (Ch'ien-lung) (1736–1795) having been superseded by the *famille rose* palette introduced into China at the end of the Kangxi period.

106 Saucer dish

A finely potted porcelain saucer dish, the sides fluted; decorated in *famille verte* enamels, painted with a wave border, the well painted with a boy arranging flowers in a vase; the base glazed and with underglaze blue double ring containing a seal.
d. 14 cm
Famille verte Porcelain
Jingdezhen (Ching-tê Chên) region
Jiangxi (Kiangsi) province
Kangxi (K'ang-hsi) period (1662–1722)
Qing (Ch'ing) Dynasty
56.27.746
Bought from Norwich City Museums, 1956

107 Bowl

A porcelain bowl with rounded sides with very slightly flared rim; the inside decorated in *famille verte* enamels, the border of peony and scroll design, underneath which is painted a band of tree peony; the outside of the bowl of 'powder blue' ground decorated in gold with scrolling chrysanthemum heads; the base glazed and with a double ring in underglaze blue containing a Buddhist emblem.
d. 18·5 cm
Famille verte porcelain
Jingdezhen (Ching-tê Chên) region
Jiangxi (Kiangsi) province
Kangxi (K'ang-hsi) period (1662–1722)
Qing (Ch'ing) Dynasty
M1901
Given by Joseph Mayer, 1867

108 Vase

A thickly potted porcelain vase with tapering sides, probably originally of rouleau form; decorated in *famille verte* enamels, the sides painted with Shaolu (Shao-lu) and figures together with a roe-deer in a continuous landscape; the base glazed and the wide footrim unglazed. The side has been repaired and the neck cut off and ground smooth.
h. 58 cm
Famille verte porcelain
Jingdezhen (Ching-tê Chên) region
Jiangxi (Kiangsi) province
Kangxi (K'ang-hsi) period (1662–1722)
Qing (Ch'ing) Dynasty
62.122.12
Given by the Miss Bannantynes, 1962

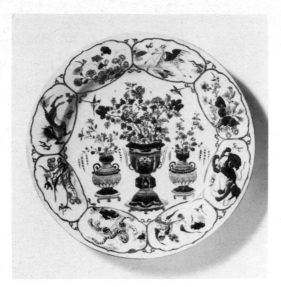

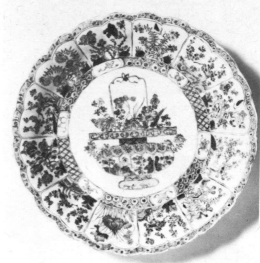

109 Plate

A thinly potted porcelain plate with everted rim; decorated in *famille verte* enamels, the border finely painted with panels containing chrysanthemum, iris, peony, carnation interspersed by *kylin*, winged roe-deer dragon-dog, and tiger, the well painted with floral arrangements contained in three vases; the footrim unglazed, the base glazed and painted in underglaze blue with a six character Kangxi (K'ang-hsi) mark within a double ring.

d. 34 cm
Famille verte porcelain
Jingdezhen (Ching-tê Chên) region
Jiangxi (Kiangsi) province
Kangxi (K'ang-hsi) period (1662–1722)
Qing (Ch'ing) Dynasty
M1885
Given by Joseph Mayer, 1867

110 Pair of shallow dishes

A pair of porcelain dishes with segmented sides; each decorated in *famille verte* enamels, the border painted with peony, lotus, chrysanthemum, orchids and other flowering blossom, the well painted with a hanging basket containing various flowers; the footrim unglazed, the base glazed and painted in underglaze blue with a swastika motif contained within a double ring.

d. 35·5 cm
Famille verte porcelain
Jingdezhen (Ching-tê Chên) region
Jiangxi (Kiangsi) province
Kangxi (K'ang-hsi) period (1662–1722)
Qing (Ch'ing) Dynasty
57.73.1 & 57.73.2
Bequest of Mrs Williamson, 1957
per National Art Collections Fund

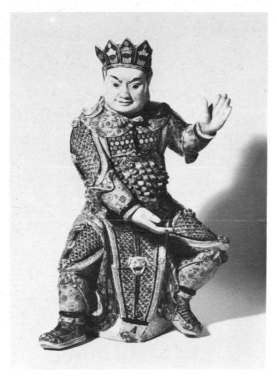

111 Pair of figures
A pair of thickly potted porcelain figures of Guandi (Kuan-ti), one brandishing a sword, both in full armour; covered overall in a transparent glaze and painted in *famille verte* with flower heads on the chest and calves. Both figures are chipped.
h. 61 cm
Famille verte porcelain
Jingdezhen (Ching-tê Chên) region
Jiangxi (Kiangsi) province
Kangxi (K'ang-hsi) period (1662–1722)
Qing (Ch'ing) Dynasty
52.48.1
Given by Miss Johnston, 1952

14c) Famille Noir
Famille noir was distinguished by A. Jacquemart in the 19th century. It is a term which applies to a derivative of *famille verte* whose colour is found on porcelains from the reign of Kangxi (K'ang-hsi) onwards. The dominant background colour is a green-black, produced by covering a brownish-black pigment with a thin wash of a glossy, transparent green lead glaze. The wash was of identical composition to the covered pigment, and produced an iridescent sheen. The process required a high number of firings which often destroyed the objects in the kiln. A variation on some vases including jars and bottles was simply to cover the object with a black glaze without the coating of green.

112 Teapot and lid
Porcelain teapot of baluster form with domed lid, straight spout and pipe handle; the sides and lid decorated with two vignetted landscapes later enamelled in black in the 19th century. The spout is chipped and has a crack.
h. 14 cm incl. lid
Famille noire porcelain
Jingdezhen (Ching-tê Chên) region
Jiangxi (Kiangsi) province
Kangxi (K'ang-hsi) period (1662–1722)
Qing (Ch'ing) Dynasty
53.120.2
Bought from Mrs Nelson, 1953

113 Cup and saucer
A very thinly potted cup and saucer of egg-shell type porcelain with everted lip; the borders of cracked ice design, the interior of the bowl painted with a cockerel, the outside with three panels of roe-deer; the saucer with matching decoration; the base glazed and footrim of both unglazed; later enamelled in black in the 19th century.
d. of Cup 6·5 cm, d. of Saucer 10·5 cm
Famille noire porcelain
Jingdezhen (Ching-tê Chên) region
Jiangxi (Kiangsi) province
Kangxi (K'ang-hsi) period (1662–1722)
Qing (Ch'ing) Dynasty
1973.126.119
Transferred from the Walker Art Gallery, 1973
Given by Mr Warrens, 1946

14d) Famille Rose

The enamel which came to be known as *famille rose* was discovered in Europe in 1650 by Andreas Cassius of Leyden. It was produced from a mixture of gold chloride and tin, giving a purple colour which was first used by enamellers in Nuremburg. The new palette was introduced into China some fifty years later at the end of the Kangxi (K'ang-hsi) period where initially it consisted of a thick overglaze red and an opaque white. In its earliest use *famille rose* was employed in conjunction with *famille verte*, the colour that it quickly surpassed in popularity. It was not until the reign of Yongzhent (Yung-cheng) and more particularly that of Qianlong (Ch'ien-lung), that the palette adopted the whole range of shades from the palest pink to the deepest crimson which are suggested by its name.

The main centre of production of the enamel was at Canton, whilst the majority of the porcelain was manufactured in Jingdezhen (Ching-tê Chên) in Kiangxi (Kiangsi) province. Many of the *famille rose* wares display the Cantonese style of painting. It has been suggested that either the undecorated wares were transported to Canton for completion, or that the painters from Canton occasionally worked at Jingdezhen (Ch'ing-tê Chên).

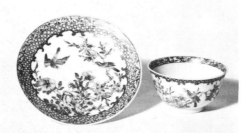

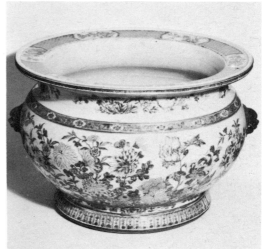

114 Cup and saucer

An egg shell porcelain cup and saucer; painted in *famille rose* enamels, the border painted *en grisaille* with a cell pattern with gilt scroll decoration, the well and sides of the cup painted with birds in a peony tree; covered overall in a bluish-white glaze, the footrims unglazed, the bases glazed.
d. of saucer 11·4 cm, h. of cup 3·8 cm
Famille rose porcelain
Jingdezhen (Ching-tê Chên) region
Jiangxi (Kiangsi) province
Yongzheng (Yung-chêng) period (1723–1735)
Qing (Ch'ing) Dynasty
1973.126.90
Transferred from the Walker Art Gallery, 1973

115 Fish bowl

A large heavily potted fish bowl with rounded sides and ledge rim; decorated in *famille rose* enamels painted around the rim with a brocaded ground with six panels containing in turn, lotus, prunus or chrysanthemum; the sides painted with chrysanthemum, peony and flowering blossom and having two moulded Buddhist lion masks; the broad footring and base unglazed.
d. 58 cm, h. 39 cm
Famille rose porcelain
Jingdezhen (Ching-tê Chên) region
Jiangxi (Kiangsi) province
Qianlong (Ch'ien-lung) period (1736–1795)
Qing (Ch'ing) Dynasty
M2081
Given by Joseph Mayer, 1867

116 Small bowl

A fairly thickly potted porcelain bowl with
rounded sides on a high footring; decorated in
famille rose enamels, the interior painted with a
border interspersed with four panels of
chrysanthemums, the well painted with a peony
flower, the exterior with a border of hawthorn
blossom upon a ground of cracked ice, and the
sides with a celestial palace wall, in a landscape;
the base glazed and the footrim unglazed.
d. 15 cm
Famille rose porcelain
Qianlong (Ch'ien-lung) period (1736–1795)
Qing (Ch'ing) Dynasty
1973.126.121
Transferred from the Walker Art Gallery, 1973
Given by Mr Warrens, 1946

117 Vase and cover

A heavily potted porcelain vase and cover of
balaster form, the lid domed and with finial;
painted in *famille rose* overglaze enamels with a
border of brocade design, the sides painted with a
cockerel, upon fungus facing another cockerel
surrounded by tree peony; the footrim unglazed.
h. 18 cm
Famille rose porcelain
South China
Qianlong (Ch'ien-lung) period (1736–1795)
Qing (Ch'ing) Dynasty
56.27.734
Bought from Norwich City Museums, 1956

118 Vase

A beaker vase from the same set as **117** with
matching decoration.
h. 14 cm
Famille rose porcelain
South China
Qianlong (Ch'ien-lung) period (1736–1795)
Qing (Ch'ing) Dynasty
56.27.735
Bought from Norwich City, Museums, 1956

119 Plate

A fairly thickly potted porcelain plate with
slightly rounded rim; decorated in *famille rose*
enamels, the well painted with a knarled tree
stump of prunus intertwined with tree peony.
d. 21 cm
Famille rose porcelain
Jingdezhen (Ching-tê Chên) region
Qianlong (Ch'ien-lung) period (1736–1795)
Qing (Ch'ing) Dynasty
63.1.103
Bequest of Mrs Stannard, 1963

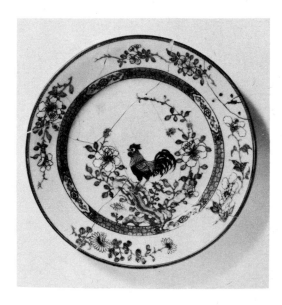

120 Plate

An eggshell porcelain plate with slightly rounded
rim; decorated in *famille rose* enamels, the border
painted with four boughs of blossom, the well
painted with a cockerel standing upon fungus, the
footrim unglazed.
d. 22 cm
Famille rose porcelain
Jingdezhen (Ching-tê Chên) region
Qianlong (Ch'ien-lung) period (1736–1795)
Qing (Ch'ing) Dynasty
1978.361.6
Source not known

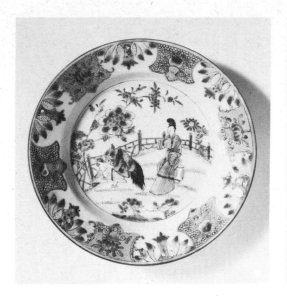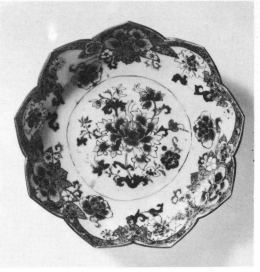

121 Plate
A fairly thickly potted porcelain plate with
slightly rounded rim; decorated in *famille rose*
enamels, the border painted with lotus flower,
peach and pumpkin, the well painted with a lady
seated in a garden observing a cockerel and a hen.
d. 22 cm
Famille rose porcelain
Qianlong (Ch'ien-lung) period (1736–1795)
Qing (Ch'ing) Dynasty
56.27.736
Bought from Norwich City Museums, 1956

122 Pair of dishes
A pair of thickly potted porcelain dishes of lotus
flower form on an unglazed footring; decorated in
famille rose enamels with peony flowers and asters.
d. 22 cm and 23 cm
Famille rose porcelain
South China
Qianlong (Ch'ien-lung) period (1736–1795)
Qing (Ch'ing) Dynasty
1973.126.86
Transferred from the Walker Art Gallery, 1973
Given by Mr Warren, 1946

123 Dish
A porcelain dish with everted rim; decorated in
famille rose enamels overglaze, the rim painted
with geese in the skies and on land, the well
having a barbed edge border and painted with a
stork amidst chrysanthemums and peonies; the
footrim unglazed.
d. 35 cm
Famille rose porcelain
Jingdezhen (Ching-tê Chên) region
Qianlong (Ch'ien-lung) period (1736–1795)
Qing (Ch'ing) Dynasty
63.1.94
Bequest of Mrs Stannard, 1963

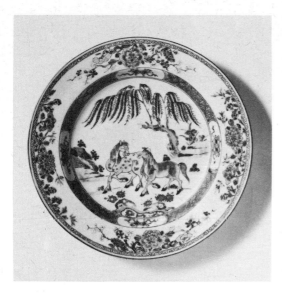

125 Butter tub, lid and stand
A fairly thickly potted porcelain butter tub, stand and lid of scalloped form to a European design on an unglazed flat base; decorated in *famille rose* enamels overglaze; the rim painted with four sprays of flowers, the well with barbed edge border painted with a peacock and hen standing upon rocks with various flowers in bloom, the lid with a handle in the form of a buddhist lion.
h. 11 cm
d. of bowl 13 cm
d. of stand 19 cm
Famille rose porcelain
South China
Qianlong (Ch'ien-lung) period (1736–1795)
Qing (Ch'ing) Dynasty
56.27.732
Bought from Norwich City Museums, 1956

124 Plate
A thinly potted porcelain plate with slightly rounded rim; finely decorated in *famille rose* enamels, painted around the rim with a scroll border and with four groups of peony, chrysanthemum, prunus and bamboo, the well painted with two cavorting horses; in the background a willow tree and to the right fungus; the footrim unglazed, and the plate edge gilded.
d. 21 cm
Famille rose porcelain
Jingdezhen (Ching-tê Chên) region
Early Qianlong (Ch'ien-lung) period (1736–1795)
Qing (Ch'ing) Dynasty
11.3.90.17
Given by the Miss Ashtons, 1890

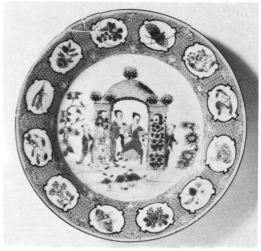

126 Plate
A porcelain plate with slightly everted rim; decorated in *famille rose* enamels overglaze, the border painted with reserves of insects and botanical studies upon a cell ground of turquoise, the well painted with two figures under an arbour, before a pond; the footring unglazed.
The plate is cracked.
d. 23 cm
Famille rose porcelain
Jingdezhen (Ching-tê Chên) region
Qianlong (Ch'ien-lung) period (1736–1795)
Qing (Ch'ing) Dynasty
11.3.90.15
Given by the Miss Ashtons, 1890

127 Cup and saucer
A fairly thickly potted porcelain cup with handle
and saucer; decorated in *famille rose* enamels with
the Sailors Farewell; the base glazed and the
footrim unglazed.
d. of saucer 12 cm, h. of cup 6·8 cm
Famille rose export ware
South China
Qianlong (Ch'ien-lung) period (1736–1795)
Qing (Ch'ing) Dynasty
1973.126.94
Transferred from the Walker Art Gallery, 1973
Given by Mr Warrens, 1946

128 Pair of salts
A pair of heavily potted porcelain salts of oval
shape; decorated in *famille rose* enamels overglaze,
the wells painted with fungus, asters, peony and
passion flower; the bases with barbed edge border,
one cracked.
l. 8 cm
Famille rose porcelain
South China
Jiaqing (Chia-ch'ing) period (1796–1820)
Qing (Ch'ing) Dynasty
56.27.747 & 56.27.748
Bought from Norwich City Museums, 1956

14e) Mandarin palette wares
During the reign of Jiaqing (Chia-ch'ing) the use
of iron red with the *famille rose* pigments
produced a somewhat harsh purplish colour which
characterises this ware.

129 Vase and cover
A fairly thickly potted porcelain vase of waisted
baluster form with short neck and domed cover;
decorated in *mandarin* palette with two panels of
figures on a gold-decorated ground; the base
glazed and the footring unglazed. The neck has
been repaired.
h. 27 cm
Mandarin palette porcelain
Jiaqing (Chia-ch'ing) period (1796–1820)
Qing (Ch'ing) Dynasty
63.1.83
Bequest of Mrs Stannard, 1963

130 Bowl
A porcelain bowl with rounded sides on a narrow
unglazed foot; decorated in *mandarin* palette in
sepia, yellow, green, brown, blue, aubergine, iron
red, the inside with a cell border and painted with
a peony spray, the outside with palace garden
scenes and panels containing birds.
d. 26 cm
Mandarin palette porcelain
Jiaqing (Chia-ch'ing) period (1796–1820)
Qing (Ch'ing) Dynasty
1966.125.4
Bought Shropshire, 1966

131 Bowl
A thickly potted porcelain bowl with rounded
sides and crenelated rim upon an unglazed
footring; decorated in the *mandarin* palette in
sepia, yellow, green, brown, blue, aubergine, iron
red, the inside with a barbed edge border and a
painted peony flower, the outside with palace
terrace scenes and vignetted landscapes. The bowl
has been broken and mended.
d. 22 cm
Mandarin palette porcelain
Jiaqing (Chia-ch'ing) period (1796–1820)
Qing (Ch'ing) Dynasty
63.1.90
Bequest of Mrs Stannard, 1963

14f) Dehua (Tê-hua) porcelain

The porcelain production of Fujian province was centred on Dehua (Tê-hua), seventy-five miles north of the port of Amoy. Dehua (Tê-hua) wares were made of a highly vitrified, fine, white porcelain, covered with a dense, high-fired glassy glaze which blends so well with the body that it is difficult to distinguish where one ends and the other begins. At its finest the fabric has the appearance of congealed fat or milk white blancmange. It is usually a yellowish-white, the colour of ivory, and highly translucent with a surface something like European soft-paste, but can also range from a cold bluish or greenish tint, more like ordinary hard porcelain, to a pinkish-white.

In Europe it is better known by the French name of *blanc de Chine*. The Chinese book of kiln sites, the Tao-lu, states that porcelain manufacture began at Dehua (Tê-hua) in the Ming dynasty (1368–1643), generally, it is thought, in the latter part. However, Honey (Honey, 1945) argues that the perfection of material and technique demonstrated in the earliest known examples of blanc de Chine could not have been achieved without a long period of experiment, possibly dating back to the Song (Sung) dynasty (960–1279AD).

The earliest known products of Dehua are figures of Kuan-yin and Maitreya from the Ming period. Most of the pieces which reached Europe date from the reign of Kangxi (K'ang-hsi) or later. By the 18th century the type was widely distributed in Europe and had become comparatively cheap. As with a lot of Chinese export ceramics, *blanc de Chine* was sometimes made to the order of foreign customers, and sometimes copied from the shapes of contemporary English silver or German and English stoneware such as porringers, mugs and tankards. The Fujian (Fukien) kilns also produced figures of Bodhidharma, Taoist immortals and caricatures of foreigners.

132 Cup

A finely potted white glazed porcelain cup with everted rim, the sides with an inscription in Grass script, fitted with a silver handle, rim and foot which appear to be of European origin.
d. 9 cm, h. 7 cm
Dehua (Tê-hua) ware
Dehua (Tê-hua) region
Fujian (Fukien) province
Kangxi (K'ang-hsi) period (1662–1722)
1978.361.13
Source not known

133 Pair of incense burners

A pair of thickly potted bluish-white glazed porcelain models in the form of Buddhist lions, upon square bases; both slightly chipped.
h. 36 cm
Dehua(Tê-hua) ware
Dehua (Tê-hua) region
Fujian (Fukien) province
Qianlong (Ch'ien-lung) period (1736–1795)
Qing (Ch'ing) Dynasty
63.1.81 & 63.1.82
Bequest of Mrs Stannard, 1963

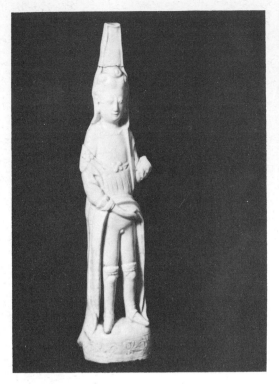
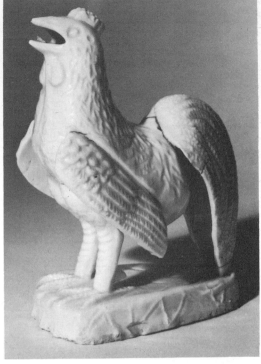

134 Figure of a woman
A white porcelain pornographic model of a
woman wearing European dress, hairstyle and
boots, holding up her dress, upon a lotus base,
carved around the base with scrolling lotus
covered overall in a yellowish-white glaze. The left
arm is missing and the head cracked.
h. 41 cm
Dehua (Tê-hua) porcelain
Dehua (Tê-hua) region
Fujian (Fukien) province
Qianlong (Ch'ien-lung) period (1736–1795)
Qing (Ch'ing) Dynasty
1978.361.14
Source not known

135 Model of a cockerel
A white glazed porcelain model of a standing
cockerel, with beak open as if crowing; covered in
a bluish-white glaze.
h. 17 cm
Dehua (Tê-hua) ware
Dehua (Tê-hua) region
Fujian (Fukien) province
Qianlong (Ch'ien-lung) period (1736–1795)
Qing (Ch'ing) Dynasty
M1402
Given by Joseph Mayer, 1867

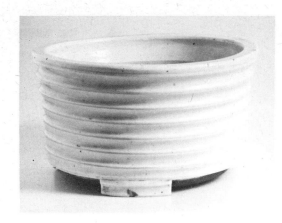

14g) Monochrome wares
The Chinese themselves favoured the monochrome wares, which are probably the most beautiful wares of the Qing (Ch'ing) dynasty. Both form and the richness of glaze are combined to the best advantage, the finest examples dating from the reign of Yongzheng to that of Qianlong.

136 Bulb bowl
A circular white porcelain bulb bowl with everted rim, standing upon three feet, the sides with radial decoration; covered overall in a yellow-white glaze; the inside and convex base unglazed.
d. 23·5 cm
Dehua (Tê-hua) ware
Dehua (Tê-hua) region
Fujian (Fukien) province
Kangxi (K'ang-hsi) period (1662–1722)
38.117.73
Bequest of Miss Weightman, 1938

137 Vase
A thickly potted porcelain vase of sprinkler form, covered in a 'Lang-Yao' red flambé glaze; the base glazed and the heavy footrim unglazed.
h. 38·5 cm
Monochrome glazed porcelain group
Jingdezhen (Ching-tê Chên) region
Jiangxi (Kiangsi) province
Jiaqing (Chia-ch'ing) period (1796–1820)
Qing (Ch'ing) Dynasty
1972.122.3762
Transferred from the Walker Art Gallery, 1972

138 Vase
A thickly potted porcelain vase with spherical
body and long flared back; covered in a dark blue
glaze, the base and footrim biscuit.
h. 35·5 cm
Monochrome glazed porcelain group
Jingdezhen (Ching-tê Chên) region
Jiangxi (Kiangsi) province
Qianlong (Ch'ien-lung) period (1736–1795)
Qing (Ch'ing) Dynasty
1972.126.3914
Transferred from the Walker Art Gallery, 1973

139 Vase
A thickly potted porcelain vase of sprinkler form;
covered in a fine dark blue glaze; the foot rim
knife pared and unglazed and the base glazed,
with painted 6 character seal mark of Qianlong
(Ch'ien-lung).
h. 41·5 cm
Monochrome glazed porcelain group
Jingdezhen (Ching-tê Chên) region
Jiangxi (Kiangsi) province
Qianlong (Ch'ien-lung) period (1736–1795)
Qing (Ch'ing) Dynasty
1973.126.3913
Transferred from the Walker Art Gallery, 1973
Given by Miss Coltart, 1946

14h) 'Rouge de fer' porcelain

This name is given to porcelain with overglaze iron red enamelled decoration, usually in combination with overglaze gilding, which was first produced during the reign of Kangxi (K'ang-hsi). It is uncommon to find a piece of this ware with a reign mark. One piece in the collection **143)** which is of very high quality bears that of Yongzheng (Yung-Chêng).

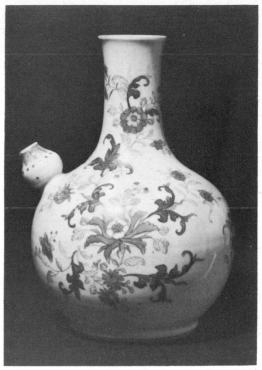

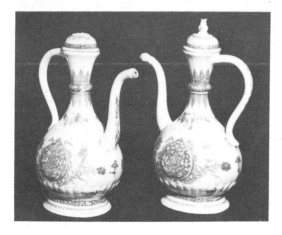

140 Pair of wine jugs

A pair of fairly thickly potted porcelain wine jugs imitating a Persian silver form; painted in iron red and gilt; the sides with a moulded panel in the form of a lotus bud containing a lotus against cloud scrolls, the neck painted with stiff stylized leaves; covered overall in a faint bluish translucent glaze. The mouth rim and footrim unglazed, the base glazed.

h. 28 cm
Rouge de fer group of porcelain
Jingdezhen (Ching-tê Chên) region
Jiangxi (Kiangsi) province
Kangxi (K'ang-hsi) period (1662–1722)
Qing (Ch'ing) Dynasty
49.62.111 & 49.62.112
Given by Mrs Newberry, 1949

141 Wine bottle

A thickly potted porcelain wine bottle of Kendi type; decorated in iron red, brown and gilt with peony and asters, upon a knife pared foot rim; covered in a blue-white transparent glaze, the base glazed and the mouth rim unglazed.

h. 20 cm
Rouge de fer group of porcelain
Jingdezhen (Ching-tê Chên) region
Jiangxi (Kiangsi) province
Kangxi (K'ang-hsi) period (1662–1722)
Qing (Ch'ing) Dynasty
49.62.105
Given by Mrs Newberry, 1949

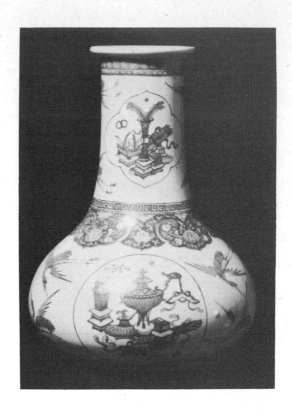

142 Vase

A fairly finely potted porcelain vase of sprinkler form; decorated in iron red and gilt with the 18th Lohan Budaiheshang (Pa-tai-ho-shang), the Buddha of the future; covered overall in a light bluish-white transparent glaze, the footrim unglazed and the base glazed.

h. 22 cm

Rouge de fer group of porcelain

Jingdezhen (Ching-tê Chên) region

Jiangxi (Kiangsi) province

Kangxi (K'ang-hsi) period (1662–1722)

Qing (Ch'ing) Dynasty

49.62.110

Given by Mrs Newberry, 1949

143 Vase

A thickly potted porcelain vase with rounded sides, tapered cylindrical neck and ledge rim, decorated in iron red and gilt, the neck with a cell border, and two quatrefoil motifs containing items from the *boku* (po-ku) interspersed on each side by storks, the lower border of cloud collar type, and the rounded sides also decorated with items from the *boku* (po-ku) and storks; covered in a bluish translucent glaze; the glazed base with an underglaze six character mark of Yongzheng (Yung-chêng) within a double circle; the footrim unglazed.

h. 21·5 cm

Rouge de fer group of porcelain

Jingdezhen (Ching-tê Chên) region

Jiangxi (Kiangsi) province

Yongzheng (Yung-chêng) period (1723–1735)

Qing (Ch'ing) Dynasty

49.62.127

Given by Mrs Newberry, 1949

14i) Chinese Imari porcelain
As its name suggests, this ware was broadly speaking copying Japanese Imari porcelain, using predominantly iron red and blue with some of the coloured enamels in the Japanese palette. The first pieces, made for export to Holland and Europe, were produced during the reign of Kangxi (K'ang-hsi) and continued to be produced into the reign of Qianlong (Ch'ien-Lung).

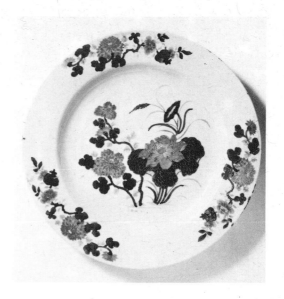

144 Bowl and cover
A porcelain bowl and cover with straight sides; decorated in underglaze blue, iron red and terracotta, the sides painted with leaf-form panels each containing a phoenix; the base glazed and the footrim unglazed.
h. incl. lid 16·5 cm
Chinese Imari ware
Jingdezhen (Ching-tê Chên) region
Jiangxi (Kiangsi) province
Kangxi (K'ang-hsi) period (1662–1722)
Qing (Ch'ing) Dynasty
56.27.754
Bought from Norwich City Museums, 1956

145 Dish
A porcelain dish with slightly everted rim; painted in underglaze blue, iron red and gilt with a border composed of three sprays, each containing chrysanthemum and peony, the well painted with lotus and chrysanthemum; the base glazed and with radial marks and footrim unglazed.
d. 39 cm
Chinese Imari ware
Jingdezhen (Ching-tê Chên) region
Jiangxi (Kiangsi) province
Kangxi (K'ang-hsi) period (1662–1722)
Qing (Ch'ing) Dynasty
1974.24.77
Given by Miss Read, 1974

14j) Jesuit ware porcelain
This is another export ware made to order for European countries, especially Holland. It was first produced during the second half of the 17th century. Later pieces, mainly dating from the Qianlong (Ch'ien-lung) period, were usually painted in grey or black with biblical scenes. The decoration gave rise to the belief in the west that Jesuit missionaries were responsible for its production, and hence the name.

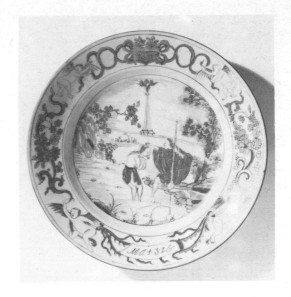

146 Tankard
A thickly potted porcelain bell shaped tankard imitating a silver form, painted *en grisaille* with two European men and a woman beneath a tree with a figure looking on; the base glazed and the footrim unglazed.
h. 16 cm
'Jesuit-ware'
Jingdezhen (Ching-tê Chên) region
Jiangxi (Kiangsi) province
Qianlong (Ch'ien-lung) period (1736–1795)
Qing (Ch'ing) Dynasty
54.171.637
Given by Mr Shore, 1954

147 Three plates
Three matching porcelain plates, fairly thinly potted, of Jesuit type painted in *rouge de fer* with a border of angels and foliage including the inscription MAT. 3.16., the well painted with Christ baptising St John the Baptist.
d. 24 cm
'Jesuit ware'
Jingdezhen (Ching-tê Chên) region
Jiangxi (Kiangsi) province
Qianlong (Ch'ien-lung) period (1736–1795)
Qing (Ch'ing) Dynasty
49.62.146, 49.62.147, 49.62.148
Given by Mrs Newberry, 1946

14k) Plastic decorated porcelain
The use of applied plastic decoration became popular on export ware during the reign of Yongzheng (Yung-chêng) and probably continued to be made into the reign of Qianlong (Ch'ien-lung). The earlier pieces are decorated in the *famille verte* palette, and the later wares in the *famille rose* palette.

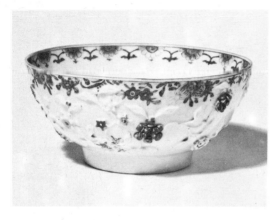

148 Bowl
A small bowl with rounded sides; decorated on the outside with 'plastic-decoration' in the form of scrolling tree peony, the border painted in enamels with chrysanthemum, peony, aster, Buddha's handcitron, and peaches.
d. 17 cm
'plastic decorated' porcelain
Yongzheng (Yung-chêng) period (1723–1735)
Qing (Ch'ing) Dynasty
63.1.87
Bequest of Mrs Stannard, 1963

149 Teapot and lid
Teapot and lid of baluster form, the sides half gadrooned and with a pipe handle and a domed lid; 'plastic decoration' to the sides in the form of hanging baskets, aster and peony; the base glazed and the narrow footrim unglazed.
h. incl. lid 14 cm
Famille rose 'plastic decorated' ware
Jingdezhen (Ching-tê Chên) region
Jiangxi (Kiangsi) province
Qianlong (Ch'ien-lung) period (1736–1795)
Qing (Ch'ing) Dynasty
M1972
Given by Joseph Mayer, 1867

150 Cream jug and basin
A fairly thinly potted porcelain cream jug of baluster form with a pipe handle and sparrow beak spout, with 'plastic decoration' in the form of fruiting sprigs and the accompanying bowl with everted rim; both with glazed bases and unglazed footrims.
d. of bowl 11·5 cm, h. of jug 11 cm
'plastic decorated' ware
Jingdezhen (Ching-tê Chên) region
Jiangxi (Kiangsi) province
Yongzheng (Yung-chêng) period (1723–1735)
Qing (Ch'ing) Dynasty
M1702
Given by Joseph Mayer, 1867

151 Teaset
A thickly potted teaset consisting of teapot, cream jug, spoon tray, tea pot, cup and saucer, and cup and saucer with handle; with segmented decoration and with applied 'plastic decoration' in the form of a squirrel in a tree.
h. of teapot with lid 15 cm
h. of cream jug 9 cm
h. of tea pot 9 cm
h. of cup 3 cm
h. of cup with handle 5 cm
'plastic decorated' ware
Qianlong (Ch'ien-lung) period (1736–1795)
Qing (Ch'ing) Dynasty
54.185.232 to 238
Given by Mr Shore, 1954

14l) Armorial ware porcelain
Perhaps the most famous export ware of all is the
Armorial ware porcelain, decorated with heraldic
devices, coats of arms and monograms. The
earliest examples were made during the reign of
Yongzheng (Yung-chêng). A large dish (151)
decorated with the arms of Utrecht belongs to
this period. The early pieces were usually in the
famille verte palette, whilst the later pieces, made
during the reign of Qianlong (Ch'ien-lung), were
characteristically painted in the then fashionable
famille rose palette.

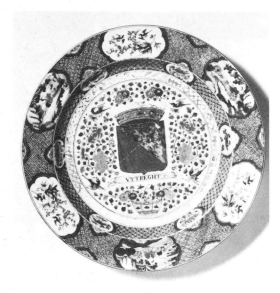

152 Large armorial dish
A porcelain dish with slightly everted rim;
decorated in underglaze blue with a brocaded
border, painted in *famille verte* enamels with six
panels of vignetted landscapes and bird panels,
the *cavetto* decorated in overglaze enamels with an
armorial design of the city of Utrecht; partly
unglazed footring and oxidised brown. The plate
has been broken and mended.
d. 47 cm
Export Porcelain armorial design
Jingdezhen (Ching-tê Chên) region
Yongzheng (Yung-chêng) period (1723–1735)
Qing (Ch'ing) Dynasty
M1708
Given by Joseph Mayer, 1867

153 Armorial dish
A thinly potted porcelain circular dish with
rounded sides and shallow footring; decorated in
overglaze coloured enamels, the inside border
painted with two vignetted landscapes and
armorial designs, the well painted with a cock and
hen pheasant upon a fungus in front of a tree
peony; the base glazed, the footrim unglazed.
d. 26 cm
Export porcelain with armorial design
Jingdezhen (Ching-tê Chên) region
Qinglong (Ch'ien-lung) period (1736–1795)
Qing (Ch'ing) Dynasty
53.120.8
Bought from Mrs Nelson, 1953
Note: The arms are those of DAVIS and SOUTHERNE
in pretence (Howard, 1974, 320 J3)

154 A part dinner service
Eleven pieces from a porcelain dinner service;
painted in overglaze enamels, the outer border of
archaic key fret design, the well border of barbed
edge design, painted in the centre with a floral
spray, with an armorial design between the
borders.
4 saucers each d. 15·8 cm, 3 plates each d. 23 cm
2 dishes each d. 22·5 cm, 2 bowls each d. 24 cm
Export porcelain with armorial design
South China
Qianlong (Ch'ien-lung) period (1736–1795)
Qing (Ch'ing) Dynasty
55.20.10,11,12 & 13
Given by Miss Coltart, 1955

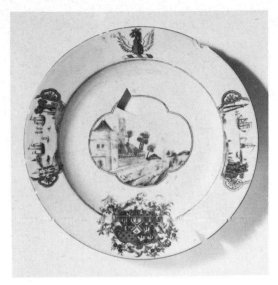

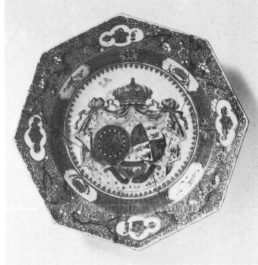

155 Armorial plate
A porcelain plate painted in overglaze coloured
enamels, the border painted with armorial
designs and harbour scenes, the well painted with
a canal scene; the footrim unglazed. The plate
has been broken and mended.
d. 23 cm
Export porcelain with armorial design
South China
Qianlong (Ch'ien-lung) period (1736–1795)
Qing (Ch'ing) Dynasty
50.139.8
Given by Mrs Buckley, 1950
Note: The arms are those of COOKE quartering
WARREN with TWYSDEN in pretence (Howard 1974,
325 J5)

156 Armorial plate
A thickly potted porcelain plate of octagonal
form; on a low footring; covered in a thick
translucent glaze; painted in overglaze coloured
enamels, the border with plum blossom, the well
with barbed edge border in gold and with an
armorial design; the footrim unglazed, the
exterior painted in iron red with four peonies;
repaired.
d. 23 cm
Export porcelain with armorial design
South China
Qianlong (Ch'ien-lung) period (1736–1795)
Qing (Ch'ing) Dynasty
53.120.11
Bought from Mrs Nelson, 1953
Note: The plate has the motto of the Lennox
family, the motto and arms of the Order of the
Garter, and an unidentified coat of arms.

157 Tureen and lid
A thickly potted porcelain tureen of oval form with applied hogshead side handles, the domed lid with scroll handle, decorated in underglaze blue around the lid, rim and foot, and painted in overglaze enamels with a repeated armorial design, with gilded rope design borders; the foot rim unglazed; repaired.
h. 24 cm
Export porcelain with armorial design
South China
Qianlong (Ch'ien-lung) period (1736–1795)
Qing (Ch'ing) Dynasty
53.120.1
Bought from Mrs Nelson, 1953
Note: The arms are those of ELPHINSTONE (Howard 1974, 973 U2)

158 Armorial plate
A porcelain plate of octagonal form; decorated in mandarin palette with a barbed edge border in gilt around the rim; painted in overglaze coloured enamels with sprays of flowers, the well painted with an armorial design.
d. 21 cm
Export porcelain with armorial design
South China
Jiaqing (Chia-ch'ing) period (1796–1820)
Qing (Ch'ing) Dynasty
53.120.9
Bought from Mrs Nelson, 1953
Note: The arms are those of PIERSON (Howard 1974, 489, p.20).

159 Armorial cup and saucer
A porcelain cup with handle and saucer; decorated in mandarin palette, the border of tooth design with garlands, and painted with a monogrammed cartouche; with unglazed knife pared footrim; repaired.
h. 6 cm
Export porcelain armorial design
Jiaqing (Chia-ch'ing) period (1796–1820)
Qing (Ch'ing) Dynasty
54.171.764
Given by Mr Shore, 1954

160 Armorial soup plate
A porcelain soup plate of octagonal form; decorated in mandarin palette, the border painted with roses, the well painted with an armorial design; cracked.
d. 23 cm
Export porcelain armorial design
South China
Jiaqing (Chia-ch'ing) period (1796–1820)
Qing (Ch'ing) Dynasty
1966.125.8
Bought Shropshire, 1966

161 Armorial plate
A porcelain plate of octagonal form with unglazed footrim; decorated in mandarin palette; painted around the rim and border of the well in underglaze blue with a broad brocaded border and barbed edge border, and painted in the centre with an armorial design; traces of gilt to the rim; repaired.
d. 24 cm
Export porcelain armorial design
South China
Jiaqing (Chia-ch'ing) period (1796–1820)
Qing (Ch'ing) Dynasty
53.120.10
Bought from Mrs Nelson, 1953
Note: The arms are those of SMITH impaling CAZALET (Howard 1974, 734 V14)

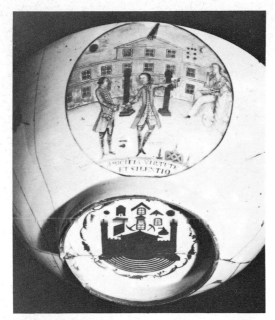

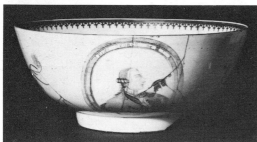

YIXING (I-HSING) WARES

The provincial kiln of Yixing (I-Hsing) is situated on the west bank of Daihu (T'ai-hu) lake, opposite Shanghai in Jiangsu (Kiangsu) province. Its most important products, the unglazed teapots, are supposed to have been made first by the potter Gongchun (Kung Ch'un) during the reign of the Ming emperor Zhengde (Chêng-tê) (1506–1521). He was followed by a large number of other master potters through the 16th and 17th centuries, many of whom are known from their marks stamped on the bases of the teapots. The fabric for which the Yixing kilns are best known is a clay which ranges from chocolate coloured to reddish or buff brown, sometimes as the result of a mixture of clays. The material is very plastic and suitable for moulding and incising and for the application of relief decoration. It was high fired to stoneware hardness, sometimes acquiring a glossy sheen in the kiln, and sometimes it was burnished on a lapidary's wheel to the same effect. The clay was occasionally speckled with quartz to give a pear-skin appearance.

'ROBIN'S EGG' WARE

The characteristic mottled effect of a purple-blue over a turquoise blue glaze was effected by use of blowing the pigment through a straw.

162 Punch bowl
A thinly potted porcelain bowl with rounded sides on a high footring; decorated in pink, yellow, green, orange, blue, white and sepia enamels, the interior with barbed edge border and a spray of rose, the outside with a named portrait of George III and the allegory 'Amicitia Virtute et Silentio', the base glazed and decorated in gold with a masonic temple and symbols; the footrim unglazed; extensively repaired.
d. 30 cm
Export porcelain portrait-type
Jingdezhen (Ching-tê Chên) region
Qianlong (Ch'ien-lung) period (1736–1795)
Jiangxi (Kiangsi) Province
Qing (Ch'ing) Dynasty
1978.361.19
Source not known

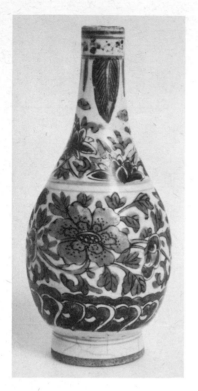

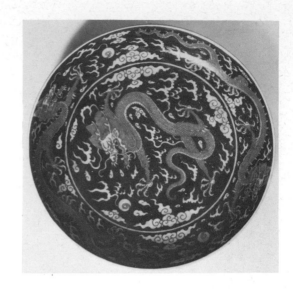

163 Sprinkler vase

A thickly potted porcelain vase, painted in
Wucai style in underglaze blue, and with
overglaze red, green, yellow and aubergine with a
main band of continuous tree peony, the neck
decorated with long stylised leaves; covered
overall in a transparent bluish glaze; the base
glazed, the footrim knife pared and oxidised
orange.
h. 19 cm
Wucai (Wu-Ts'ai) group of porcelain
South China
Early 17th century
Ming Dynasty
1976.159.259
Bought from Cheltenham College for Boys, 1976

164 Shallow dish

A finely potted porcelain shallow dish of fine
body, the sides rounded; painted inside in yellow
enamel on a blue ground with a dragon chasing
the flaming pearl; the base with the seal
character mark of Qianlong (Ch'ien-lung) in
underglaze blue.
d. 15 cm
Yellow and blue enamelled group of porcelain
Jingdezhen (Ching-tê Chên) region
Jiangxi (Kiangsi) province
Qianlong (Ch'ien-lung) period (1736–1795)
Qing (Ch'ing) Dynasty
57.185.21
Bequest of Mrs Smith, 1957
cf Gulland (1902) vol.II figs.874–875

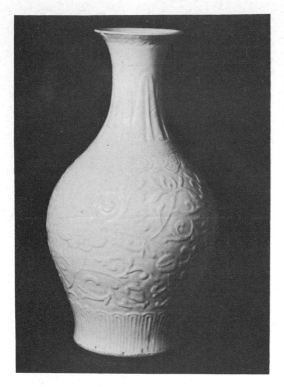

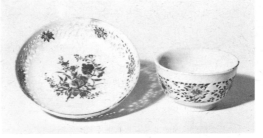

165 Vase
A finely potted white porcelain vase with rounded
sides and everted rim, the neck carved in low
relief with stiff leaves, the sides decorated with
scrolling lotus and peony; covered overall in a
bluish-white glaze.
h. 31 cm
White glazed porcelain
Jingdezhen (Ching-tê Chên) region
Jiangxi (Kiangsi) province
Kangxi (K'ang-hsi) period (1662–1722)
Qing (Ch'ing) Dynasty
56.27.317
Bought from Norwich City Museums, 1956
cf Hobson (1925–1928) vol.5, pl.lxi, E344

166 Cup and saucer
A porcelain cup and saucer; the cup with pierced
decoration, the interior painted in enamels with a
selection of flowers; the saucer with rounded sides
and a pierced border, the well painted with a
selection of flowers, peaches etc; the bases of each
glazed, the footrings unglazed.
d. of saucer 14 cm, d. of cup 9 cm
Porcelain with pierced decoration
Jingdezhen (Ching-tê Chên) region
Jiangxi (Kiangsi) province
Yongzheng (Yung-chêng) period (1723–1735)
Qing (Ch'ing) Dynasty
M1950
Given by Joseph Mayer, 1867

167 Bowl
A fairly thickly potted porcelain bowl with
rounded sides; decorated in overglaze enamels,
the interior painted with tree peony, the exterior
moulded with a brocaded pattern and painted
with four circular panels containing floral
arrangements and scholars items; the base glazed
and incised with a lotus flower, the footrim
unglazed.
d. 19·5 cm
Porcelain with moulded decoration
Jingdezhen (Ching-tê Chên) region
Jiangxi (Kiangsi) province
Yongzheng (Yung-chêng) period (1723–1735)
Qing (Ch'ing) Dynasty
11.3.90.10
Given by the Miss Ashtons, 1890

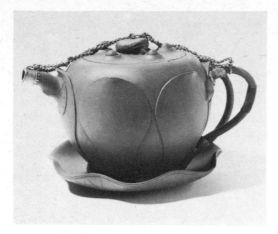

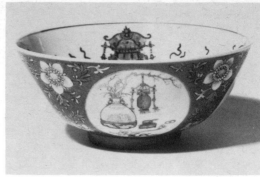

168 Teapot, lid and stand
Finely potted teapot and stand of reddish-brown
stoneware carved in the form of a lotus bud, the
spout in the form of a notched stem, the handle in
the form of two flower stems; the lid decorated
with five nodules and with a model of a toad; the
lid fitted with gilded metallic mounts; the stand in
the form of a lotus leaf.
h. of teapot 9 cm, d. of stand 11 cm
Yixing ware
Jiangsu (Kiangsu) province
Kangxi (K'ang-hsi) period (1662–1722)
Qing (Ch'ing) Dynasty
M1993
Given by Joseph Mayer, 1869

169 Bowl
A porcelain bowl with slightly rounded sides and
slightly everted lip; the interior painted in
underglaze blue with four lanterns, the outside
decorated in coloured enamels, on a 'graviata'
ground, with four circular panels painted with
lanterns; the glazed base with a six-character seal
mark of Daoguang (Tao-Kung) in underglaze
blue; the footrim unglazed.
d. 14·5 cm
Enamelled porcelain
Jingdezhen (Ching-tê Chên) region
Jiangxi (Kiangsi) province
Daoguang (Tao-kung) period (1821–1850)
Qing (Ch'ing) Dynasty
1976.159.260
Bought from Cheltenham College for Boys, 1976

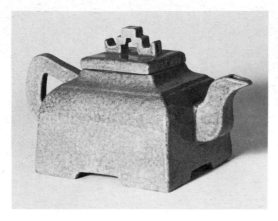

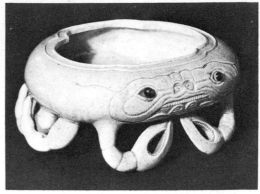

170 Teapot and cover

A thickly potted white porcelain teapot and cover of beehive form with square section handle and spout; the exterior covered in a 'robin's egg' glaze, the four right-angle bracket feet unglazed on the edge; the interior white-glazed; the base glazed.
h. incl. lid 12 cm
'Robin's egg' glazed porcelain
Jingdezhen (Ching-tê Chên) region
Jiangxi (Kiangsi) province
Kangxi (K'ang-hsi) period (1662–1722)
Qing (Ch'ing) Dynasty
38.117.86
Bequest of Miss Weightman, 1938

171 Dish

A white porcelain dish in the form of a crab; the exterior covered with a 'robin's egg' glaze; the inside with a turquoise coloured glaze; the right-hand claw cracked and the lid missing.
h. 13 cm, w. 25 cm
'Robin's egg' glazed porcelain
Jingdezhen (Ching-tê Chên) region
Jiangxi (Kiangsi) province
Qianlong (Ch'ien-lung) period (1736–1795)
Qing (Ch'ing) Dynasty
26.4.88.59
Bought from Mr Cross, 1888

172 Small bowl

A small fairly thinly potted bowl and lid; the bowl with slightly conical sides and concave base, of grey porcellanous stoneware; decorated with incised floral sprays; covered in a thin pale sage-green celadon glaze; the base glazed, the footring unglazed and oxidised red; the lid conical with a button finial decorated with concentric circles in relief.
h. 9·7 cm incl. lid
Fujian (Fukien) province 17th century
38.117.82
Bequest of Miss Weightman, 1938

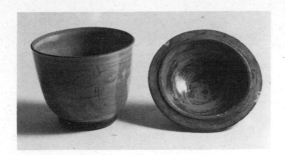

15 Uncertain and spurious wares

The section contains a number of pieces of uncertain date and origin but they are included here for the sake of completeness together with items that are of doubtful age, and which are classed as spurious.

173 Small bowl

A finely potted bowl and lid; the bowl with slightly conical sides and concave base; of grey porcellanous stoneware; decorated with incised floral and foliage sprays; covered in a thin pale sage-green glaze; the base glazed, the footring unglazed and oxidised red; the lid conical with a button finial and decorated with concentric circles in relief.
h. 10·5 cm incl. lid
Fujian (Fukien) province
17th century
38.117.81
Bequest of Miss Weightman, 1938

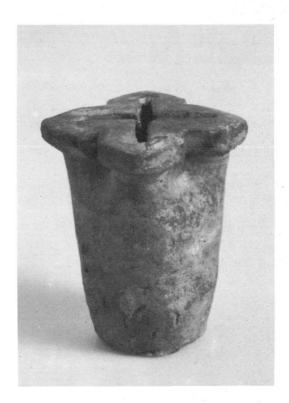

174 Money box or burner from a model stove
A small vessel of pink earthenware, the sides indented at the top, with a fixed square cover having a cut out opening in the form of a cross and a wedge shape cut from each side; the upper part covered in a green lead glaze partly eroded and with some iridescence.
h. 10·5 cm
Green lead glazed earthenware
1976.159.262
Bought from Cheltenham College for Boys, 1976

175 Small vase

A vase of brown stoneware with slightly flared
rim; covered in a brilliant turquoise glaze
running on to the square cut foot, the unglazed
areas oxidised dark brown.
h. 10·75 cm
Imitation Jun (Chün) ware
Fujian (Fukien) province
18th century
1978.361.26
Transferred from Walker Art Gallery

176 Vase

A vase of grey earthenware; decorated with two
carved Taotieh (Tao-Tieh) masks and with two
bands of incised lines; covered in a black slip
with painted decoration in vermilion. The vessel is
coated with buff earth.
h. 20·5 cm
Tin foil type
Early Han Style
Probably 20th century
56.39.4
Bought from R. C. Terry, 1956
Note: R. C. Terry considered this vase to be of the
Chang-Sha 'Tin foil' type, based upon a paper by
Newton (Newton, 1949) but there are certain
major differences between the pieces discussed
there and this one. No chemical analysis was made
on the vase by Terry.

177 Armorial salt

A thickly potted porcelain salt with gold barbed
edge border; the footrim unglazed and flat, the
well painted in overglaze enamels with armorial
design.
l. 7·5 cm
Imitation export porcelain armorial design
20th century
50.28.8
Bequest of Miss Walker, 1950

16 Provincial wares

Pottery and porcelain in the Chinese tradition
were produced both to the south and to the north
east of China. The wares made in Korea, in
particular, follow types current in China, including
at various times Yue (Yüeh), Ru (Ju), Cizhou
(Tz'u-chou), Ding (Ting) and celadon wares. The
Koreans adapted to their own tastes Chinese
techniques and styles in potting. The influences
were not necessarily all one way; it is possible that
ideas from provincial countries also exerted some
influence on Chinese potters. Certain southern
Chinese wares have been added to this section.

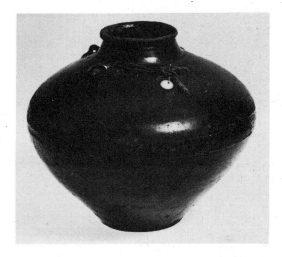

178 Jar

A storage jar of ovoid form with four cord loops
on the shoulder; the dark grey body covered in a
dark brown glaze.
h. 23·5 cm, d. 10·2 cm
Probably Korean
13th–15th century
56.26.221
Bought from Norwich City Museums, 1956
Given by Charles Hose
Collected in Borneo where used by the Malanau
tribe to gather honey
cf Hose & McDougall (1912) pl.47

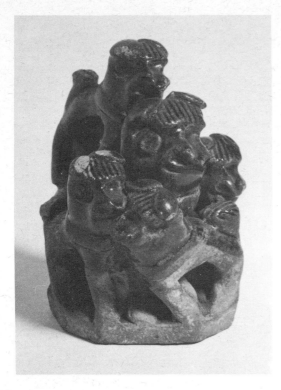

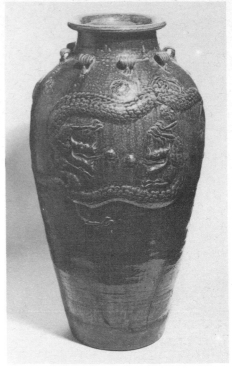

179 Model of a bitch and puppies
A buff stoneware sculptured model of a bitch and
four puppies; covered overall with a coffee-brown
glaze finishing in an uneven rim half way down the
body.
h. 8 cm
Probably southern China
Probably 10th–12th century AD
38.117.4
Bequest of Miss Weightman, 1938

180 Small vase
A bottle-shaped vase with two vertical loop
handles forming 'ears' on the shoulder; the upper
part of the body decorated with horizontal wheel
cut grooves; covered in a brown glaze terminating
in a heavy roll just above the base.
h. 11·5 cm
Sawankhalok
14th–15th century
56.27.697
Bought from Norwich City Museums, 1956
cf Gompertz (1958) pl.36A

181 Large vase
A large vase of brown stoneware, covered with a
streaked toffee-brown glaze, the shoulders
rounded, the body tapered and the mouth flared,
the neck with seven vertical lugs, the sides with
moulded decoration of four confronting dragons
each pursuing the Pearl of Wisdom.
h. 85 cm
Provincial ware
Probably 17th century
56.26.273
Bought from Norwich City Museums, 1956
Given by C. Joslyn Brooke
Collected in Borneo
cf Hose & McDougall (1912) pl.48

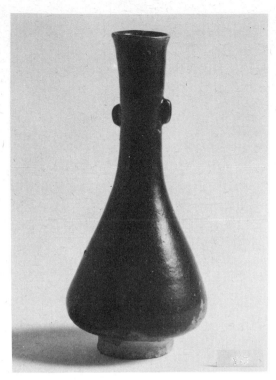

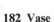

182 Vase
A vase with pear-shaped body, elongated neck
with slightly flared rim, and two lugs; the concave
base having a clay 'pantille'; covered in a dark
brown glaze.
h. 15·3 cm, d. 2·8 cm
Probably Korean
17th century
1978.361.22
Source not known

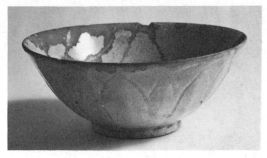

183 Bowl
A bowl with slightly rounded sides; the exterior
carved with stylised lotus petals above a deep
footring and below the everted rim, covered in a
cream slip and a transparent greenish glaze, the
footring glazed, the base unglazed. The interior
has four stilt marks.
d. 17 cm
North Vietnamese
Probably 13th century or later
1978.361.20
Source not known

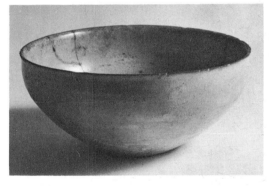

184 Bowl
A bowl with slightly everted rim and flat base with
white body covered in cream slipware and a
transparent glaze.
d. 18·4 cm
North Vietnamese
12th–13th century
1978.361.21
Source not known

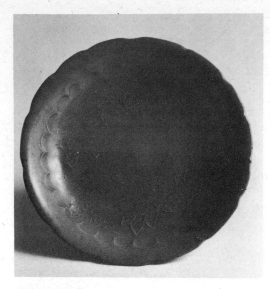

185 Small dish
A thickly potted shallow stoneware dish with
petal form rim; the interior moulded with peony
and lotus flowers, the exterior with an incised
lotus; covered in a sage-green glaze, the base and
footrim oxidised red where unglazed.
d. 16·6 cm
Provincial Celadon ware
Vietnamese
Probably 12th–13th century
38.117.20
Bequest of Miss Weightman, 1938

186 Bowl
A bowl of light buff fabric, the inside with
moulded peony flowers; covered overall in a
yellow-green glaze, the base and footring
unglazed. There is an unglazed ring around the
inside of the bowl caused by stacking the bowls
one on top of the other in the kiln.
d. 17·8 cm
Annamese
Probably 12th–13th century
38.117.48
Bequest of Miss Weightman, 1938

187 Vase
A porcellanous stoneware vase with tapered sides
and rolled rim; covered in a crackled light-green
celadon glaze ending in an uneven line above the
base; the base unglazed. There are firing cracks
at the rim and on the body.
h. 19 cm
Southern China
Probably 16th–17th century
56.26.223
Bought from Norwich City Museums, 1956
Given by Dr C. Hose
Collected in Borneo from the Malanau tribe

188 Vase
A porcellanous stoneware vase very similar in
shape to **187**, although the form of the rim is
slightly different.
h. 18 cm
Southern China
Probably 16th–17th century
56.26.224
Bought from Norwich City Museums, 1956
Given by Dr C. Hose
Collection in Borneo from the Malanau tribe

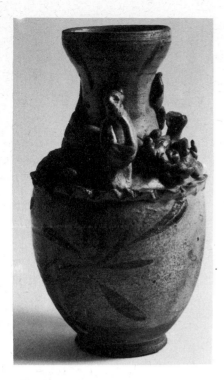

190 Small dish
A stoneware dish with a buff white body, the
sides slightly rounded, painted in underglaze blue
with four chrysanthemum heads; covered in a
bluish translucent glaze with an unglazed band
around the centre, the base and footring unglazed.
d. 18 cm
Vietnamese
Probably 17th century
1979.631
Given by Dr Bird, 1979

189 Funerary vase
A funerary vase of mallet form with splayed
footrim; painted in the Cizhou (Tz'u-Chou)
manner with floral forms in brown; the shoulders
modelled in relief above a high crust band with a
reclining figure, a standing figure in front of a
dragon, and a dog below a representation of the
moon inscribed with the character Yüeh'; the buff
body covered in a transparent glaze.
h. 26·5 cm
Southern China
Fujian (Fukien) province
Probably 14th–15th century
1978.361.23
Source not known
cf Medley (1976) figs. 42 & 66
 University of Michigan (1965) no.38

191 Bowl
A bowl of grey stoneware with designs carved and
filled with white and black clay, the interior with
inlaid decoration consisting of a central medallion
containing a crane flying amid clouds with four
medallions containing lotus sprays around,
interspersed with cranes flying among clouds;
the exterior with reversed inlaid decoration in the
form of a lotus wreath; covered overall in a
grey-green celadon glaze.
d. 18·7 cm, h. 5·9 cm
Inlaid Celadon
Korean
Koryo Dynasty
12th–13th Dynasty
38.117.44
Bequest of Miss Weightman, 1938
Bought from Bluett & Sons

Bibliography

The bibliography is composed entirely of works cited in the catalogue

Addis, J. M. (1978)	*Chinese Ceramics from Datable Tombs and some other dated materials* London
Admin Comm (1978)	*Cultural Relics Unearthed in Kwangsi Autonomous Region* Administrative Commission for Cultural Relics, Peking
Ayers, J. (1964)	*The Seligman Collection of Oriental Art* Vol. II, London
Ayers, J. (1968)	*The Baur Collection, Geneva* Geneva
Beurdeley, M. & C. (1974)	*Chinese Ceramics* London
Fenollosa, E. F. (1912)	*Epochs of Chinese & Japanese Art* London
Gompertz, G. St G. M. (1958)	*Chinese Celadon Wares* London
Gulland, W. G. (1902)	*Chinese Porcelain* 2 vols, London
Hobson, R. L. (1925–28)	*The George Eumorfopoulos Collection. Catalogues of the Chinese, Corean and Persian Pottery and Porcelain* Vol. I–VI, London
Hobson, R. L. (1948)	*Handbook of Pottery and Porcelain of the Far East in the Department of Oriental Antiquities, British Museum* London
Hochstadter, W. (1953)	*Bulletin of the Museum of Far Eastern Antiquities* 'Pottery and Stonewares of Shang, Chou and Han' Vol.24, pp.81–108, Stockholm
Honey, W. B. (1945)	*Ceramic Art of China and other Countries of the Far East* London
Hose, C. & McDougall, W. (1912)	*Pagan Tribes of Borneo* Vol.1, London
Howard, D. S. (1974)	*Chinese Armorial Porcelain.* London
Jansen, B. (1976)	*Chinese Ceramiek* Catalogus Haags Gemeentemuseum, The Hague
Joseph, A. M., Moss, H. M. & Fleming, J. J. (1970)	*Chinese Pottery Burial Objects of the Sui and T'ang Dynasties* London
Karlbeck, O. (1949)	*Transactions Oriental Ceramic Society* 'Proto-porcelain and Yüeh ware' Vol.25, pp.33–48

Koyama, F. *et al* (1955)	*Sekai Toji Zenshu* Vol.8 From Ancient China to the Six Dynasties Vol.9 Sui and T'ang Dynasties Vol.10 Sung and Liso Dynasties Vol.11 Yüan and Ming Dynasties Tokyo
Laufer, B. (1909)	*Chinese Pottery of the Han Period* Leiden
Legeza, I. L. (1972)	*Malcolm McDonald Collection of Chinese Ceramics* London
Medley, M. (1975)	*Colloquies on Art & Archaeology in Asia* 'Chinese painting and the decorative style' No.5, London
Medley, M. (1976)	*The Chinese Potter* Oxford
Newton, I. (1949)	*Transactions Oriental Ceramic Society* 'Tin Foil as a Decoration on Chou Pottery' Vol.25, pp.65–69
Newton, I. (1950)	*Transactions Oriental Ceramic Society* 'A Thousand Years of Potting in the Hunan Province' Vol.26, pp.27–36
Ridley, M. (1973)	*Treasures of China* London
Staatliche Museen (1970)	*Staatliche Museen preussicher Kulturbesitz. Museum für Ostasiatische Kunst, Katalog* Berlin
Sullivan, M. (1963)	*Chinese Ceramics, Bronzes and Jades in the Collection of Sir Alan and Lady Barlow* London
Sweetman, J. (1966)	*Chinese Ceramics, Leeds Art Gallery and Temple Newsam House* Leeds
Tokyo National Museum (1953)	*Illustrated Catalogue of Old Oriental Ceramics donated by Mr. Yokogawa* Tokyo
University of Michigan (1965)	*The Marshall Plumer Memorial Collection* University of Michigan, Museum of Art
Valenstein, S. G. (1975)	*A Handbook of Chinese Ceramics* New York
Wen-Wu (1972)	'Chronological dating and development of shapes of the T'ang period, from pieces found in the tomb near Sian' *Wen-Wu* No.3
Wirgin, J. (1979)	*Sung Ceramic Designs* London
Yao Ts'u T'u L'u (1956)	*Yao Ts'u T'u Lu* Peking

ISBN 0 906367 07 7

Merseyside County Museums
William Brown Street
Liverpool L3 8EN
051-207 0001